SANTA FE
AND TAOS

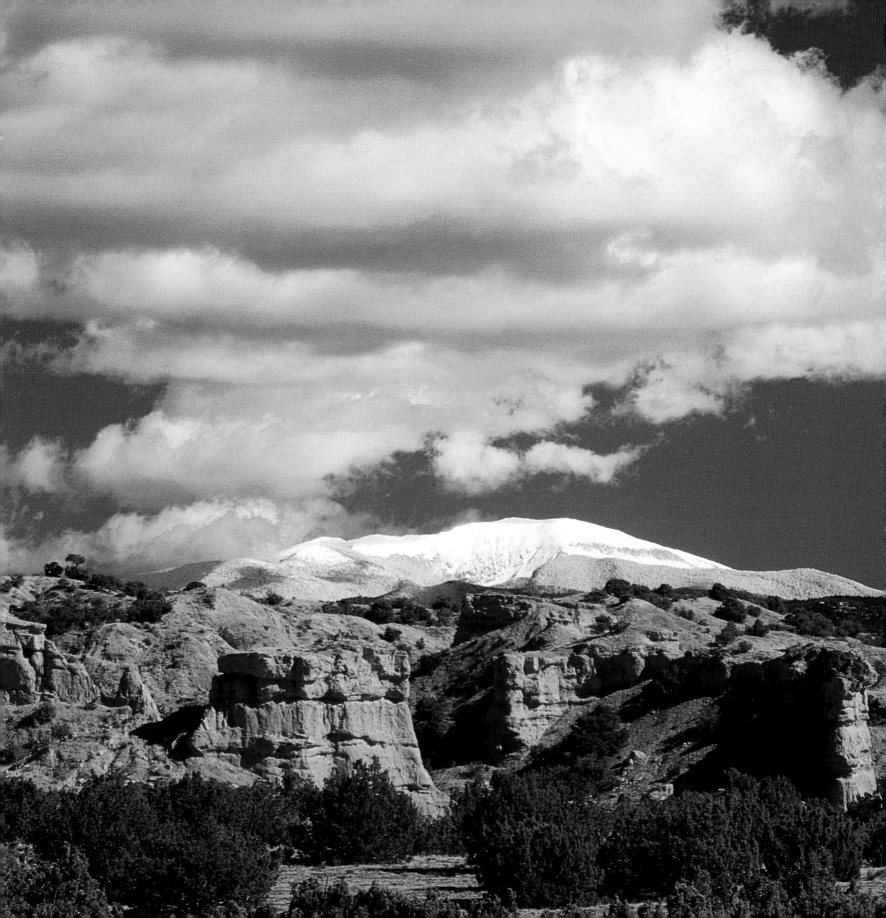

BY LANDT DENNIS

✳

PHOTOGRAPHS
BY LISL DENNIS

SANTA FE

UNDER A COYOTE MOON

AND TAOS

CHRONICLE BOOKS
SAN FRANCISCO

Library of Congress Cataloging-in-Publication Data:
Dennis, Landt.
 Santa Fe and Taos : under a coyote moon /
by Landt Dennis ; photographs by Lisl Dennis.
 p. cm.
 Includes bibliographical references and index.
 ISBN 0-8118-0896-3
 1. Santa Fe (N.M.)—Social life and customs—
Pictorial works. 2. Taos (N.M.)—Social life and
customs—Pictorial works. I. Dennis, Lisl. II. Title.
F804.S243D457 1996
978.9'56—dc20 95-30891
 CIP

Cover and text design: Rebecca S. Neimark

Printed in Hong Kong.

Distributed in Canada by
Raincoast Books, 8680 Cambie Street
Vancouver, B.C. V6P 6M9

10 9 8 7 6 5 4 3 2 1

Chronicle Books
275 Fifth Street
San Francisco, CA 94103

TABLE OF CONTENTS

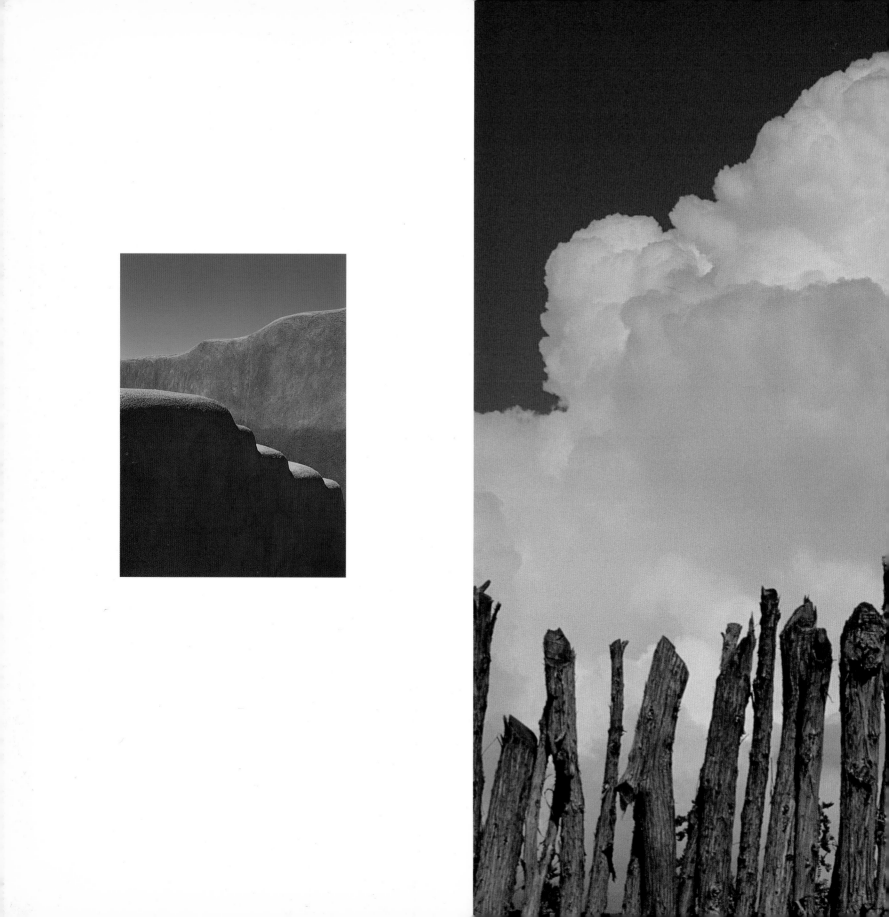

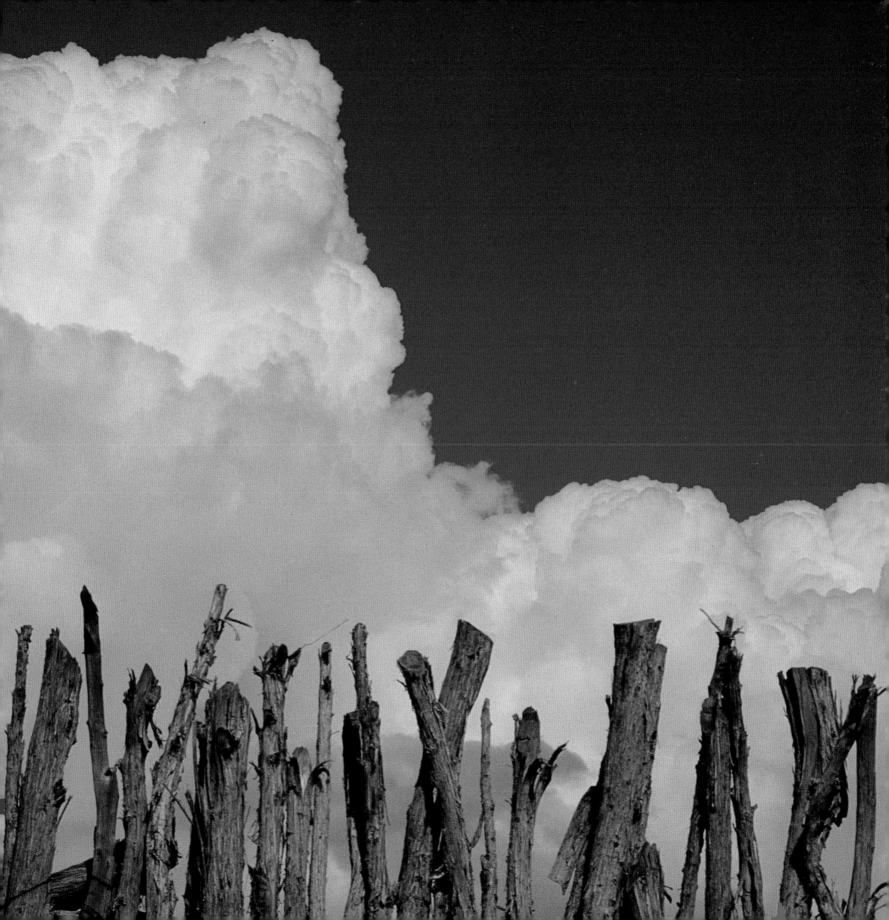

SANTA FE AND TAOS: YESTERDAY, TODAY, AND TOMORROW

In the beginning, there was the soft sound of coyote paws treading through pine needles. Then came the almost imperceptible rhythm of feet as Native Americans tilled the soil outside their pueblos along the Rio Grande. Centuries later, the land shook and reverberated with the ominous thunder of horses' hooves. ❁ Spanish conquistadores had invaded the land. ❁ Today, I-25, the main highway between the towns of Santa Fe and Taos in northern New Mexico, hums with the roar of automobiles driven by eighth-generation residents and fresh-off-the-plane, wide-eyed newcomers. Whether native or new arrival, drivers along this scenic route through the Land of Enchantment experience the same awestruck exhilaration and bone-deep wonder at the drama of the sharply drawn landscape. The spectacle of blackened buttes, crimson mesas, scorched arroyos, aspen-covered mountains, celestial blue skies, and spellbinding, massive cloud formations

left: At Spanish Market held in August in Santa Fe, merchants sell rugs imported from Mexico. With their bright colors and unusual designs, these rugs are frequently used as wall hangings in local homes.

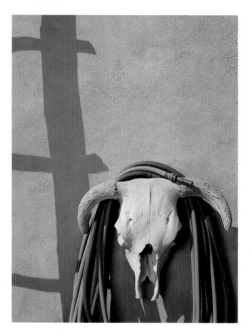

Adobe—used in construction of houses and walls around gardens—is a five-hundred-year-old tradition in Santa Fe and Taos. A mixture of mud, sand, and water (and sometimes straw), adobe keeps buildings cool in summer, warm in winter. *Vigas,* or beams, often protrude outside adobe walls.

wakens consciousness and satisfies the soul.

Santa Fe and Taos, two of the oldest settlements in the United States, have for centuries drawn and entertained enthusiastic audiences, never more so than today. Native Americans and Hispanics have been joined in recent years with a vastly expanded cast of characters, most of whom are expatriate Anglos enamored of the Left Bank of America.

The playbill includes painters, writers, poets, CEOs, film stars, scriptwriters, and diplomats. Add to the list the growing influx of truth-seekers anxious to go beyond body in pursuit of the spirit. Taos and Santa Fe newspapers, telephone books, and bulletin boards are full of the names of advisers and healers of every possible persuasion. While the centuries-old skill of Hispanic and Indian *curanderismo* (folk healing) continues, today's lineup of northern New Mexican whole-life pursuits—with hundreds of teachers willing to speed devotees on their way—

are infinite in number. Current possibilities include past life regression, powervision, eco-magic, instantaneous transformation, ascension, drumming, aura imaging, channeling, and cranio-sacral therapy.

A classified ad in the *Santa Fe Reporter* lends additional insight into the appeal of Santa Fe and Taos, both of which have had a longtime tolerance for alternative lifestyles: "Gay shaman seeks other male pagans, fairies, satyrs, horned gods and kindred spirits to create some magic and rituals together here in the Land of Enchantment." So it goes! There are also those who are fascinated with turquoise, chiles, mantras, saddles, acupuncture, hiking, burritos, blue jeans, Mozart, Haydn, Puccini, Verdi, corn dancers, fiestas, sunsets, and moonrises.

Settlers, like cheerleaders, must choose sides. Will we live in Santa Fe or will we live in Taos? Passers-through inevitably work out itineraries to include layovers in both towns. For some, it's easy. Taos—with six

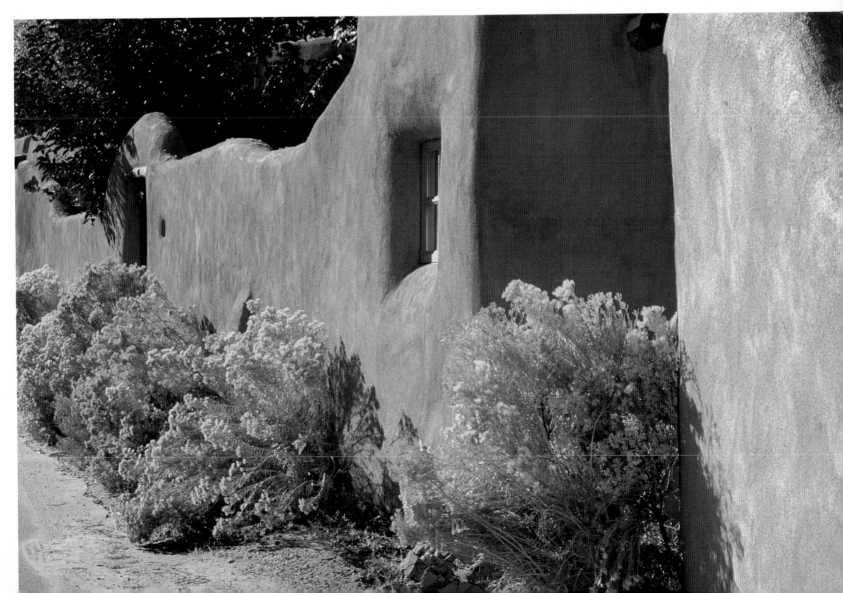

top: **During the cool summer nights in Santa Fe and Taos, outdoor adobe fireplaces are very popular.**

bottom: **When restoring an old adobe house, home-owners seek out antique Mexican and New Mexican doors and gates.**

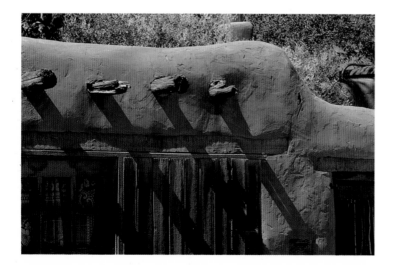

thousand residents—is touted as offering the laid-back lifestyle available in Santa Fe twenty-five years ago. Contemporary Santa Fe—with fifty-nine thousand residents, an opera, chamber music, and numerous fine restaurants—is appreciated for what it is today. The truth is, each town has a different appeal for different people. An hour and a half from one another by car, close enough historically that their roots are intertwined, the towns maintain separate identities while sharing similar histories.

The Anasazi people settled in the Southwest thousands of years ago, then mysteriously disappeared. Six or seven centuries ago, Pueblo Indians appeared in New Mexico. They established pueblos, of which sixteen remain along a seventy-five-mile stretch of the Rio Grande River to the north and south of contemporary Santa

Fe. One village was named the Dancing Ground of the Sun, an insightful description of the New Mexican High Country.

Here, seven thousand feet above sea level, the searing sun of the parched desert south of Albuquerque is tempered by shattering spring and summer rainstorms, often accompanied by dazzling triple rainbows. In winter, below-freezing temperatures can turn raindrops to snowflakes. Fall is the most colorful time. Egg-yolk-yellow chamisa and ecclesiastical purple asters stand out against piñon-covered green hills that grow higher and higher until they spill over into Colorado to become the Rockies.

In the sixteenth century, the Spanish moved in to lay claim to this land. Already in control of present-day Mexico, their galleons laden with gold claimed by the crown and their churches crowded with converts, the Spanish wanted more—more wealth, more followers of the faith. Further New World expansion was necessary to meet their greed.

Francisco Vasquez de Coronado, with three hundred soldiers, was the first to saddle up and head north from Mexico City. He set out in 1540 in search of the seven golden cities of Cibola. He failed. There was no gold. There were, however, natives who lived in houses made from adobe mixed with straw that glittered in the sun. The next expedition, under Juan de Oñate, set out to colonize the area in 1598. Philip III of Spain figured if he couldn't get gold from what the crown named Nuevo Mejico, he could at least raise his scepter over a new territory and force the inhabitants to pay taxes.

La Villa Real de la Santa Fe de San Francisco de Assis, the Royal Village of the Holy Faith of St. Francis of Assisi, or current-day Santa Fe, was founded in 1610 by Don Pedro de Peralta. The site was perfect. With water and a topography suitable for irrigation, good land to farm, forests with animals to hunt and trees to fell, the encampment—at the base of what the Spanish named the Sangre de Cristo (Blood of Christ) Mountains—grew in size and popularity.

At the northern end of the Camino Real de Tierra Adentro, or Royal Highway of the Interior, which stretched more than a thousand miles from the viceregal capital in Mexico City to the northernmost trading outposts, Santa Fe was for two-and-a-half centuries the administrative, military, and commercial center of the Spanish/Mexican frontier. A

Spring in northern New Mexico often coincides with winter. Snow-covered flowers are not uncommon.

lesser road went farther north to the Taos pueblo, where trading also took place.

While ecclesiastical resistance to military rule dominated the territory's daily life for most of the seventeenth century, the Pueblo Revolt in 1680 was the first hard blow to the Spanish presence in the area. With many of their people forced into slavery, their economy dependent on the Spanish, and their gods denigrated, the Pueblo Indians—armed with lances, bows and arrows—routed the enemy. For nine days, the battle raged. One thousand Spanish settlers, their water supply cut off and their livestock depleted, fled the town. For the next twelve years, the colonial imperialism that undermined the Indians' centuries-old way of life was gone.

In September 1692, the Spanish were back, this time under the command of Don Diego de Vargas. With two blue-robed Franciscan friars, fifty Indian auxiliaries, ten armed citizens, and forty mounted soldiers, Vargas re-entered the settlement and made a temporary peace with the Indians. A year later, an expedition of seventy families arrived, this time with Nuestra Senora del Rosario, a small statue of the Virgin, in the lead. Today, she is sheltered in the Santa Fe cathedral and brought out for special occasions.

Aware that the Spanish were serious about resettlement, the Indians launched a second battle for Santa Fe. This time, however, they lost, and Santa Fe returned to the crown, where it remained for the next two hundred years.

Now, three centuries later, evidence of Santa Fe's rich, Hispanic roots can be found throughout the town, in its street names (Paseo de Peralta, De Vargas, Acequia Madre, Coronado, Galisteo, Alameda, San Francisco, Camino del Monte Sol) and Old World family names (Chavez, Padilla, Archuletta, Garcia, Roybal). All trace their origins to the early Spanish. One family, the prominent Ortiz y Pinos, has worked its genealogy back six-

teen generations to when Nicola Ortiz and his wife, Doña Maria Coronada, moved to Santa Fe in 1693.

In the beginning, Santa Fe held no particular allure for new settlers. Although it was the provincial capital of an area that included all of present-day New Mexico and Arizona, and parts of present-day Colorado and Utah, it was in fact a small, dusty, squalid farming community of about five thousand people. For some, however, it had its attractions. It was described by one visitor as offering "licentiousness of every description" replete with "unrestrained vice," which "went on day and night" with "no time for sleep."

It was a town to be enjoyed to the fullest by Spanish and Indian traders en route to trade fairs or rendezvous, at nearby Taos and Pecos. There, a bride could be had for two buffalo hides, and a horse for twenty deerskins. Foreigners (outside merchants from the United States) were not allowed to attend the fairs, however, since the

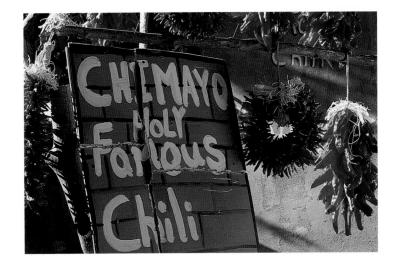

top: **New Mexican** chile peppers are world famous, especially chile peppers grown in the **Chimayo** valley north of **Santa Fe.**

bottom: Motorcyclists love traveling the back roads of **New Mexico.**

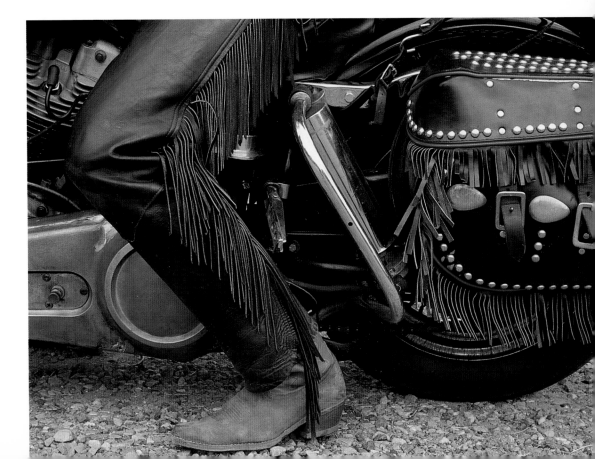

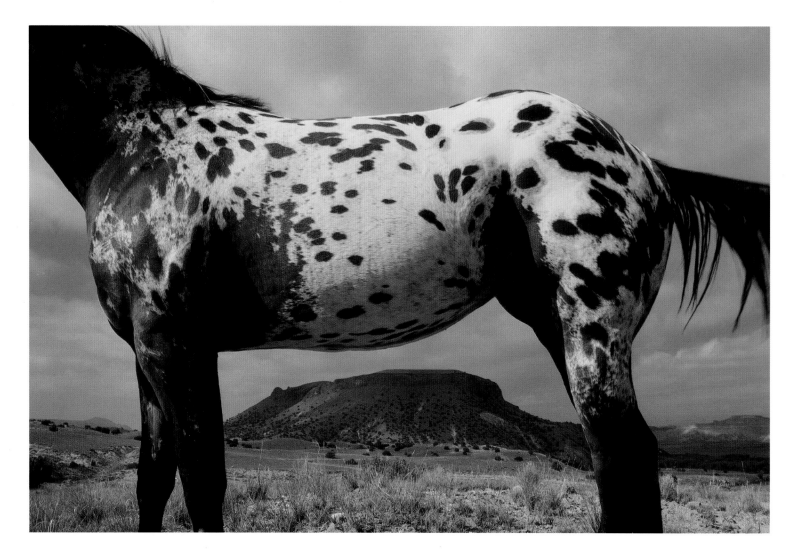

A sacred site on the
San Ildefonso
Pueblo, Black Mesa
is framed by an
Appaloosa horse.

Numerous painters,
most notably
Georgia O'Keeffe,
have captured the
beauty of the mesa.

crown could not collect taxes on their trading profits. "Gringos," in fact, weren't even allowed into the kingdom. Lieutenant Montgomery Pike learned the hard way. He was arrested in 1807 for stepping—"by mistake"—over the dividing line.

The economic and social scenes in Santa Fe changed significantly in 1821 when Mexico successfully gained its independence from Spain. Raising their flag over the plaza, the Mexicans profited enormously through increased trade with Santa Fe. The government in Mexico City was pleased to see its silver specie and gold bullion—dragged by oxen to Santa Fe and then carried further north to America—become the major means of economic exchange.

The road to riches lay along the Santa Fe Trail, which was opened up by William Becknell in 1821. Aware of the incredible wealth that traders would make selling American goods in Santa Fe, he loaded a mule train in Franklin, Missouri, with bolts of calico, kitchenware, religious medals, silk shawls, and looking glasses and headed southwest. Welcomed by Mexican soldiers when he rode into Santa Fe, he could barely tie up his horses in the plaza before he was sold out. Returning home a rich man, Becknell began what would become a stampede along the Santa Fe Trail. It was no wonder. In 1824, a freight caravan of twenty-three wagons and eighty-one men arrived in Santa Fe and turned a $35,000 investment into $180,000 worth of sales— well over $1 million in today's dollars.

Leaving Westport, Missouri—now a part of Kansas City—in the spring and arriving in Santa Fe in the early summer, freight caravans would pass in front of Santa Fe's one-story, adobe houses and be greeted by shop-till-you-drop citizens shouting, "Los Americanos! Los Carros! La entrada de la caravan!" At its peak, trail traffic employed over ten thousand men and grossed millions of dollars for both Mexican and American merchants.

Their pockets bulging with pesos, Americans quickly developed what has become a longtime love affair with northern New Mexico, especially Santa Fe and Taos. Here they found a nearby foreign nation with a foreign culture, a distinctive architecture, a memorable cuisine featuring red and green chiles, and eye-dazzling surroundings. Recognizing the Southwest's sensual appeal, a New York journalist was among the first to report home on his reaction to the area: "Its health is the best in

the country, which is the first, second, and third recommendation of New Mexico." Of Santa Fe, he concluded, "Although dirty and unkempt, and swarming with hungry dogs, [it] has the charm of foreign flavor and . . . retains some portion of the grace which long lingered about it . . ."

It was an allure that didn't go unnoticed in Washington. According to the doctrine of Manifest Destiny, New Mexico was a rightful part of the United States. Look at a map and it was obvious, Congress insisted, that New Mexico must become American. Brigadier General Stephen Watts Kearny and his "Army of the Southwest" made sure the Mexicans accepted this one-sided lesson in geography. Opposition was minimal. On August 18, 1846, under the orders of Santa Fe's acting governor, Juan Bautista Vigil y Alaraid, Mexican solders surrendered and the Stars and Stripes was raised over the plaza.

For the next seventy-five years, Santa Fe and Taos would be rough, tough South-

western frontier towns where land barons got their way. A spread of two million acres was not unusual, but no one dared to ask how the owners got it. As for the role of governor, it required little more "than to count sheep and people," wrote Governor Lew Wallace, author of *Quo Vadis*.

Once New Mexico officially became the forty-seventh state of the United States on January 6, 1912, the town at the end of the trail turned from backwater to headwater. There was no more frontier, but there was magic in them thar New Mexican hills. Both Henry Ford's invention of the Model T and the arrival of the Atchison, Topeka & Santa Fe Railroad—which dropped passengers off in Lamy, thirty minutes by car from Santa Fe—helped introduce a growing group of outsiders to the splendors of the Southwest. A spur line to the capital, used primarily for freight, was eventually wangled by Archbishop Jean Baptiste Lamy, immortalized by author Willa Cather in *Death Comes for the Archbishop*.

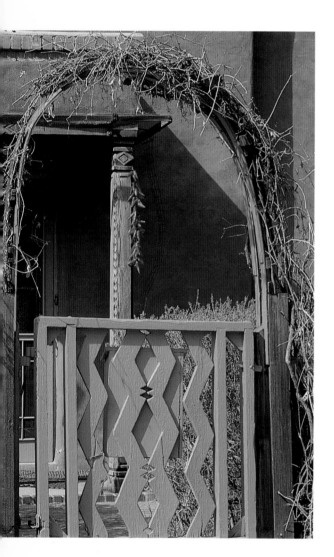

A chile *ristra*—a string of peppers—hung by a door and a blue gate are often seen in New Mexico.

Some of the newcomers had been inspired to make the stopover after reading an advertisement in the *New Mexican Review* of April 12, 1900. No other place on the American continent was more suited for the traveler to "find rest from the daily monotony of an active life and recuperate his gray matter" than New Mexico, it read. "It is an ideal spot for a summer's outing, and will compare favorably with a trip to Egypt, while not taking up so much time and being less expensive."

Forgoing the sphinx for the Palace of the Governors (the oldest government building in the U.S.), the pyramids for pueblos, many stayed overnight at the famous La Fonda Hotel in Santa Fe on the plaza. It was one of the Santa Fe–style Harvey Houses, a chain of hotels and restaurants started by Fred Harvey throughout the Southwest. Others took an Indian Detour, a guided opportunity to get off the train in Lamy, climb into the back of a Packard touring car, and explore

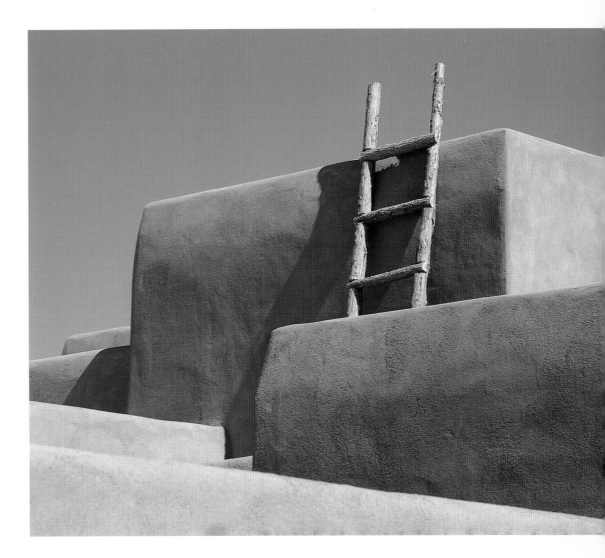

The light and shadow on the clean, cubistic walls and levels of a Santa Fe house give it the quality of an abstract painting.

For generations, residents of Santa Fe and Taos have collected Indian artifacts—including rugs, drums, and pots—to decorate their homes. Today, these artifacts have become very valuable.

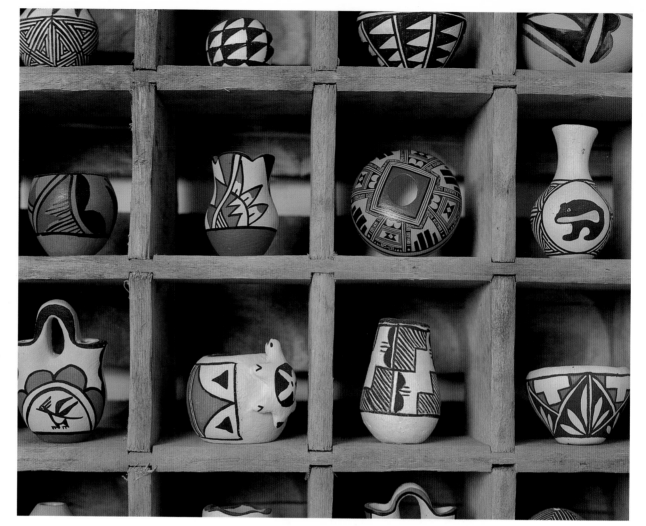

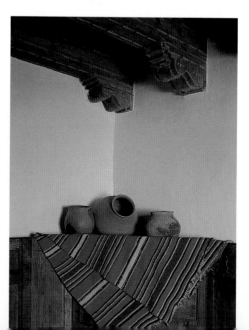

northern New Mexico, including the Four Corners region where Colorado, Utah, Arizona, and New Mexico meet.

There were also the "lungers," people with tuberculosis who came to New Mexico to check into the Sunmount Sanitarium in Santa Fe. Once cured, many of these people stayed to become some of the most colorful characters in the town's early twentieth-century folklore.

Of all the transplants to New Mexico during the first half of the twentieth century, writers and painters exclaimed the loudest to friends back home about how they had come under the spell of Santa Fe and Taos. Paul Horgan, in his book *Centuries of Santa Fe*, helps to explain the attraction. "It was always difficult to fix upon the particular stimulus amid all the general charms which had most to do with bringing modern colonists to town," he wrote. "Yet beyond these general charms something else could be felt. It was the insinuation of freedom of behavior, not in any publicly unsavory terms, but rather in an opportunity for an individual man or woman to live a life of free expression. In modern times, was this the most significant, and perhaps the most Latin, of attractions . . . ?"

More easily accessible than Taos—another rugged day's travel farther north—Santa Fe at first attracted the greatest number of painters, including William Henderson, Robert Henri, John Sloan, Randall Davey, Fremont Ellis, Will Schuster, and Marsden Hartley. John Marin put into words the underlying explanation for the influx. "My God! That such a place exists! It engulfs you," he wrote a friend. "It's the best possible place to come alive. Space . . . it's unbounded. And that sky . . . it's a blank, empty wall . . . the most powerful emptiness I've ever known."

Today, enthusiasm for the beauty of the land isn't enough for newcomers to be well received by the City Different. The rich and famous are discovering that environmental sensitivity is all important. Actress Shirley MacLaine went too far out on a limb when she attempted to raise the roof of a house on a $1.5 million, thirty-four-acre site she bought on top of an undeveloped mountain overlooking Santa Fe. Even though an Indian friend, Two Moons, gave his blessing, locals did not. Rather than try to win over a hostile audience, MacLaine beat a retreat to her 7,357-acre ranch near Abiquiu.

Earlier in the century, other seekers of

Colorful tiles, often imported from Mexico, are a common interior and exterior decoration for homes in Santa Fe and Taos. Painted windows are also popular as a decorative element.

the light occasionally moved on as well. They would stop in Santa Fe, check it out, not feel at home, then continue north, most often to bed down in Taos. An early pilgrim to Taos included Mabel Dodge Luhan, a complex, socially aggressive grande dame, who soon had scores of Eastern and European guests following in her wake. She had moved to Taos from New York after her third husband, Maurice Sterne, had written her from New Mexico to say, "Dearest Girl, do you want an object in life? Save the Indians—their art, culture—reveal it to the world."

Mabel accepted the challenge. First she divorced her husband, then married Tony Luhan from the nearby pueblo and made sure other creative people appreciated her newfound paradise. Reporting that "for the first time in my life I heard the world

singing in the same key in which my life inside me had sometimes lifted and poured itself out," Mabel was said "to collect people like flowers." Her pre–World War II bouquet included symphony conductor Leopold Stokowski, novelist-playwright Thornton Wilder, author Mary Austin, photographer Paul Strand, and critic Carl Van Vechten. Two of her greatest recruits were artist Georgia O'Keeffe, who eventually settled northwest of Santa Fe, in Abiquiu, and writer D. H. Lawrence, who moved north of Taos to Kiowa Ranch. Too much of Mabel, everyone concurred, turned wine into water.

Of all the rhapsodic insights that have been written about New Mexico's gut-level appeal, Lawrence summarized his thought with typical poetic self-analysis. "I think New Mexico was the greatest experience

from the outside world that I have ever had," he wrote of his transformation. "It certainly changed me forever . . . The moment I saw the brilliant, proud morning shine high over the deserts . . . something stood still in my soul, and I started to attend . . . In the magnificent fierce morning of New Mexico one sprang awake, a new part of the soul woke up suddenly, and the old world gave way to the new."

It is the "new" that has many old-timers upset today by what is happening in Santa Fe and Taos. They miss the fact they are not the same small, everyone-knows-everyone, off-the-beaten-track, you-can-always-park, mañana communities they were fifty years ago. But neither are St. Paul de Vence, Capri, Provincetown, or Mallorca the same tightly knit, untouched-by-mass-human-migration hideaways that they were

back when. "It is a miracle that Santa Fe and Taos haven't changed more, or been totally ruined like so many small towns have been in the United States," rightly reasons an old-timer who remembers when burros brought firewood into town and dirt roads were predominant. "Our downtowns still look pretty much the same. There are new stores, some very big-name ones. But the architectural look hasn't been drastically altered. The fact is, Santa Fe and Taos are popular because they aren't typical. They really are different."

Still, the growth problems both towns face are considerable. Neither claims to be Eden. Elected officials, historic zoning commissions, newspaper editors, the last person over the drawbridge—all these concerned citizens of Santa Fe and Taos are doing their darndest to reconcile today's

improved economics with yesterday's impoverished charm. In one of the nation's poorest states, the financial rewards of the two towns' popularity promote a tug-of-war between developers and conservationists with daily debates, public and private, in the courtrooms and at cocktail parties.

Yes, gated communities with intercoms have begun to appear in Santa Fe. There are gangs. Robberies occur, too. Yes, it takes too long to inch one's car through the traffic jams in Taos. The incoming and outgoing roads of both towns are lined with motels and tacky souvenir shops. There never has been and there isn't now enough water to satisfy expansion, especially for resort developments, hotels, and golf courses. The rising price of a roof overhead forces the sons and daughters of old-timers to move out of town. Ridge-top,

million-dollar, five-thousand-square-foot "fauxdobe" showplaces scar the skyscape.

Neither Santa Fe nor Taos is problem free. Graffiti on the wall of a bathroom in a jam-packed, highly praised restaurant full of obviously wealthy visitors focuses on the fact. "The chi-chi bird has landed with talons of silver and beak of gold. All is lost," the writer scribbled before flushing.

Lost? Uh-uh. Not yet. But it could happen unless brakes are put on real estate developments, and more energy is put into land preservation and water conservation. Meanwhile, close to two million visitors flock to the two towns each year. Whether they come to ski, browse the ever-growing number of art galleries, listen to symphony and chamber music, sip champagne between acts at the opera, or eat fritto pies at a powwow, American and for-

eign visitors alike agree that tri-cultural, Hispanic/Native American/Anglo Santa Fe and Taos are different, different from anywhere else in the United States.

Which town to see first? It doesn't matter. Flip a coin. Heads, it's Santa Fe— voted the number two U.S. city readers of *Conde Nast Traveler* would most like to visit. Tails, it's Taos. Everyone judges for himself. Each town has its critics and its claques. The turn-of-the-century camaraderie that existed among the artists and writers that headed west to settle in Santa Fe and Taos may be gone, but the enthusiasm that drew them there is not. Santa Fe's and Taos's new colonies of expatriates from New York, Los Angeles, Dallas, London, Amsterdam, and Zurich are like converts to the cross—elated, uplifted, and vocal in their newfound faith.

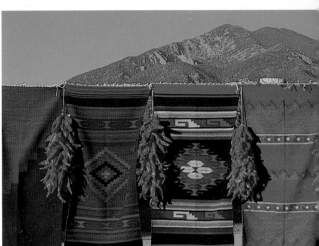

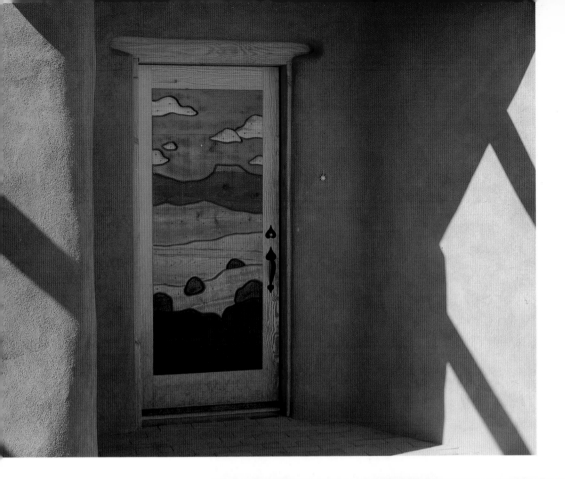

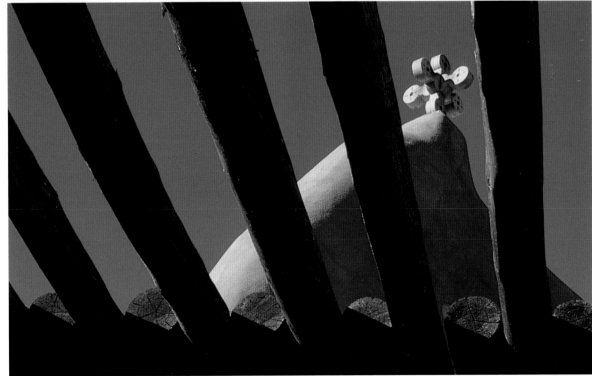

Wherever you look
in Santa Fe and
Taos, there is some-
thing to catch your
eye: a fancifully
carved front door;
Mexican rugs hung
up for sale between
chile *ristras;* an
energy symbol on
an adobe roof.

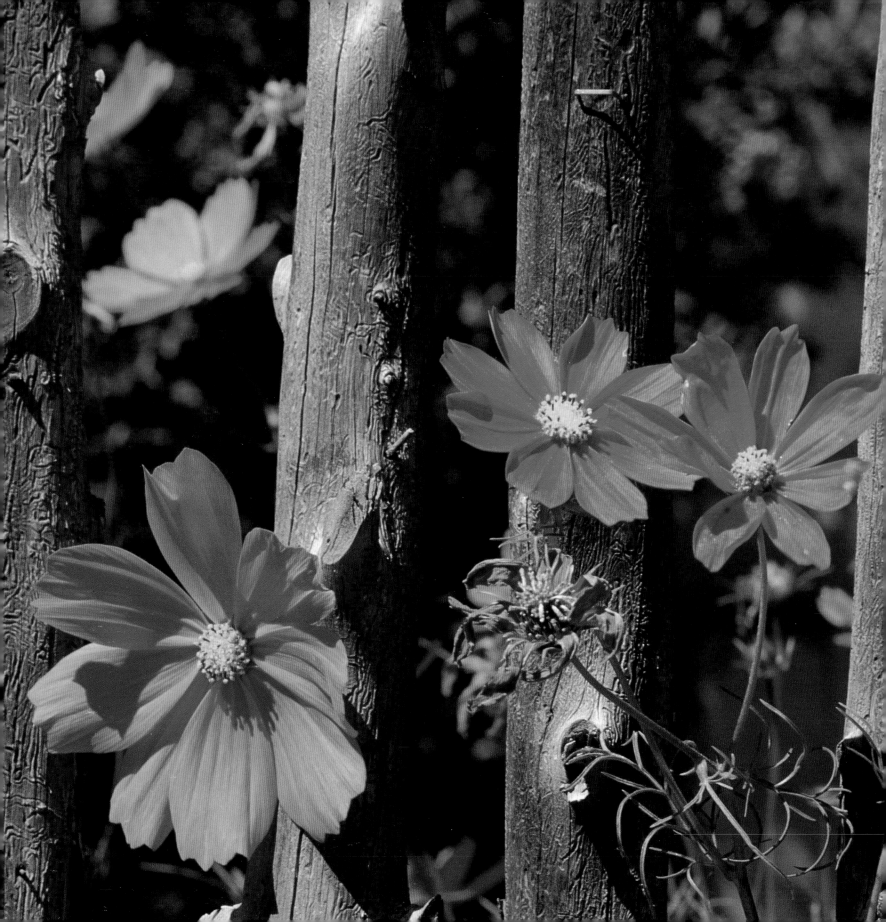

SANTA FE SUMMER

"How do you stand the summer? Isn't it unbearable?" Frequently, those who don't realize that Santa Fe and Taos are seven thousand feet above sea level think of themselves as having the intolerable heat of the desert. Wrong. While daytime temperatures in June may reach the 90s with little humidity, the thermometer retreats to the pleasant 80s in July and August and dips down to the nippy 50s almost every night. Northern New Mexican summers have long attracted Southwesterners and Middlewesterners in search of relief from the searing sun. Today, both towns draw audiences and new devotees from across the United States, and from abroad as well. ❋ Summer in Santa Fe is heralded by the lilacs of spring. For weeks, huge lavender blossoms frame doorways and windows. Backdropped by adobe walls, bushes the size of trees fill the air with the scent of Yardley bathsoap and old-fashioned talcum. In the distance, patches of snow continue to

left: Because Santa Fe and Taos are situated in high country, not desert, their gardeners are able to grow a wide variety of flowers. Here, cosmos thrust their heads toward the sun.

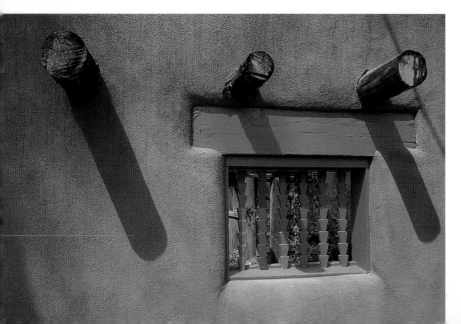

A *zia*—a sacred Indian symbol— painted across the corner of a building, geese resting on a windowsill, a brilliant blue window, lilac blossoms galore: visitors to Santa Fe have a lot to look at.

cling to the peaks of the Sangre de Cristo mountains, where skiers ride up the chair lifts until Easter.

By May 15th, bud-nipping frosts are thought to be over and gardeners begin to dig in the soil. With a willingness to water and the protection of walls, homeowners get ready for summer and the arrival of roses, lilies, peonies, penstemons, and hollyhocks. Followers of permaculture, with its emphasis on water conservation, delight in wild native grasses—needle-and-thread, sacaton, big bluestone, and bamboo muhly.

Like India, Santa Fe in summer has monsoons. Uncluttered blue skies of morning give way to late-afternoon and evening cauldrons of clouds, battleship gray and heavy with rain. Peeking over the mountaintops by lunch time, growing

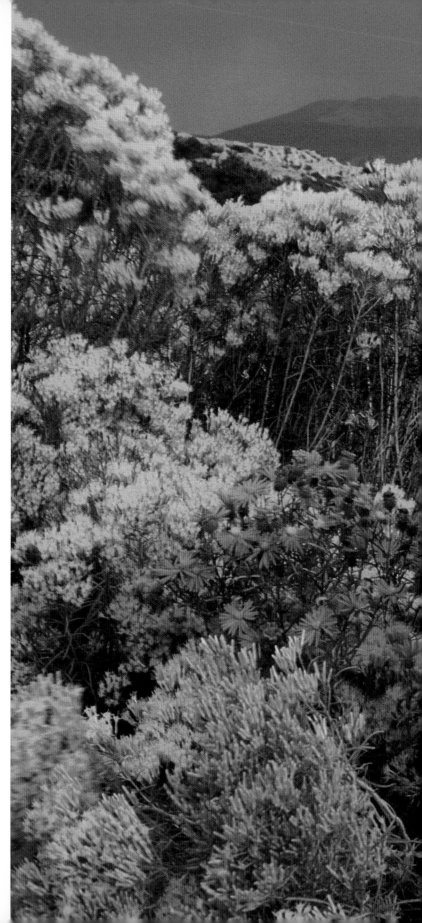

bolder by teatime, they block out the sun and blacken the sky. Suddenly, the clouds call up the lightning and summon the thunder. Rivers of water pour down upon earth. "It's raining here." "It's not raining here." Weather watchers know that the gods are unpredictable and delight in scattering their blessings. What blesses one garden doesn't always bless a neighbor's. Raindrops may be falling, but not everywhere.

For thirty minutes, an hour, maybe two, the drenching continues. Roofs leak and arroyos flood. Suddenly, the storm is over. The sun reappears. Golden in tone, it floodlights the landscape. Overhead, as many as three rainbows arch across the sky.

Summer performances in Santa Fe are dramatic, and they aren't enacted only by nature. Filling up hotels, restaurants, and intersections, visitors flock to what critics call the Salzburg of the Southwest. The Santa Fe Opera, with a July through August performance schedule, was the first musical magnet to draw international

In late summer, yellow *chamisa* and purple asters blanket the countryside between Santa Fe and Taos, with the Sangre de Cristo mountains providing a dramatic backdrop. In the winter, the mountains are covered with snow.

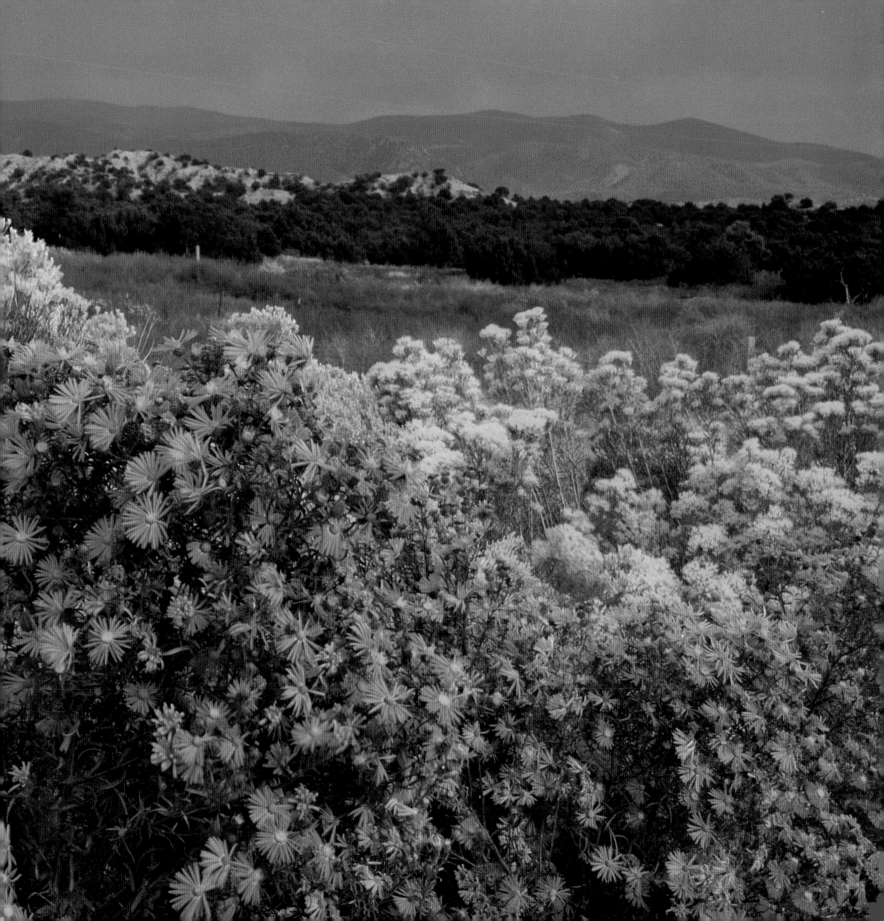

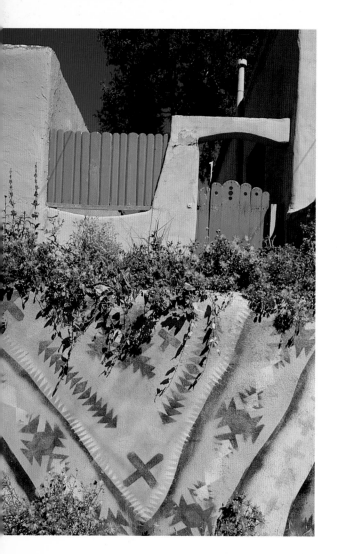

For several years,
an anonymous
artist has painted
Indian blankets on
Santa Fe walls.

audiences to town. Recalling that when he first came to Santa Fe as a boy there were no traffic lights and that "one was likely to go to the movies on horseback," John Crosby returned as an adult to become the founder and director of the opera. Undaunted when the first building was destroyed by fire, he raised the funds to construct the current opera house, which rose from the ashes in 1968. According to critic James Iema, it resembles "a great desert bird poised for flight. But its adobe-colored walls are reassuringly tireless." The building's landing pad is a plateau that perches high over town with views north to the Rockies, west to Los Alamos, and south to Albuquerque.

Often conducting the orchestra for *Elektra*, *La Traviata*, *The Magic Flute*, or *Lulu*, Crosby screens over seven hundred appli-

cants each year for forty apprentice singer positions. They compete for the chance to go west to be with such outstanding performers as Frederica von Stade, Ashley Putnam, Sherrill Milnes, Judith Blegen, and Rosalind Elias.

As for opera-goers, they call to secure tickets months ahead of time, then call for dinner reservations at a restaurant—El Nido, Palace, Pink Adobe, Escalera, Bistro, Geronimo, Santacafe, Encore Provence, Coyote Cafe, or Corn Dance. Others prefer to tailgate before the performance. Thermoses of margaritas and picnic hampers with Brie and fried chicken are opened up in the parking lot at twilight and closed by sunset, when the overture wafts over the land.

Meanwhile, downtown, the Santa Fe Chamber Music Festival fills the seats in

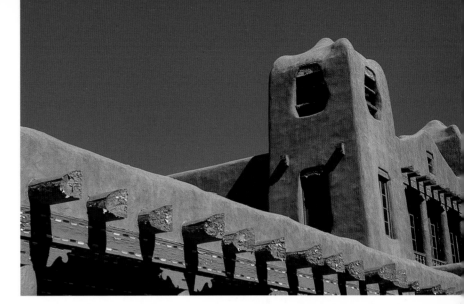

bottom: Every year, Zozobra, or Old Man Gloom, bursts into flames at the Santa Fe Fiesta.

right: Traditional adobe architecture is carefully preserved in Santa Fe's centuries-old historic district.

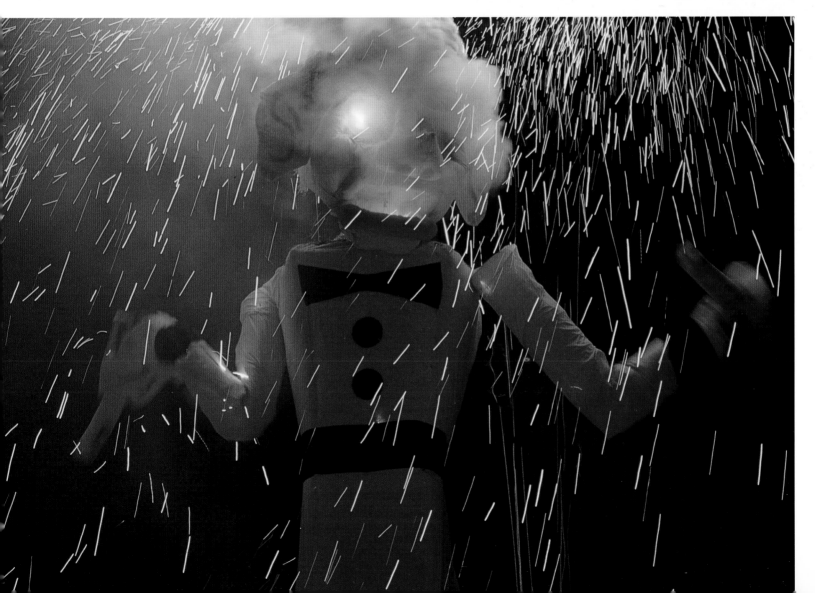

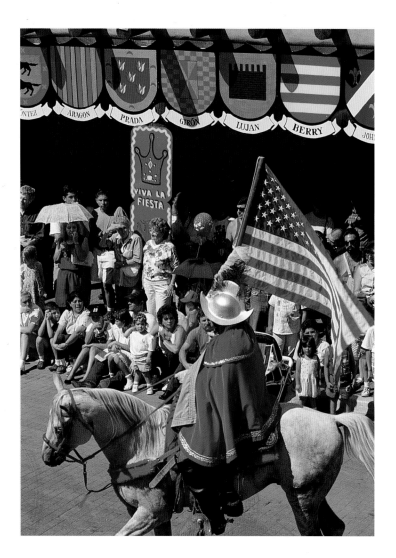

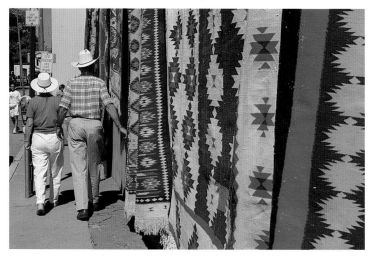

Santa Fe's Fiesta honors the recon-quest of the city from Pueblo Indians by General Don Diego de Vargas in 1692 and the subsequent return of one thousand Spanish settlers to town.

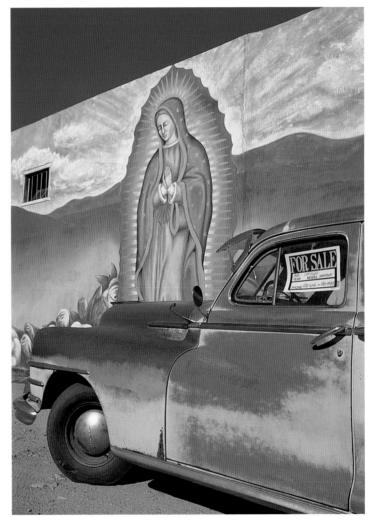

Painted on the side
of a building, the
Virgin of Guadalupe,
patron saint of

Santa Fe, protects a
city where retail
sales—art, T-shirts,
silver and turquoise

jewelry—bring in
millions of dollars
each year.

the St. Francis auditorium at the Museum of Fine Arts, and the Desert Chorale raises the roof at the Santuario de Guadalupe.

"We thought we'd relax in Santa Fe in the summer. Instead, we rarely took a siesta and found ourselves busy all the time," a first-time visitor discovered. "We'd race home from playing tennis or exploring the countryside just in time to change for the evening. You have to learn to pace yourself."

Dressed in pressed jeans, concha belts, and shined cowboy boots, Santa Feans and the city's numerous caterers are kept busy socializing and passing canapés all year long. Goodness knows, there is no lack of a recognizable guest list in this ancient town with a growing population of brand new people, including the Duke and Duchess of Bedford, who abandon Europe to tie up in Santa Fe for the summer.

California earthquakes, New York taxes, stress, burnout, the ease of the fax, the speed of the airplane—numerous factors

At Santa Fe's rodeo, pickup trucks and Range Rovers compete for parking spaces as dudes and cowboys head for the fun.

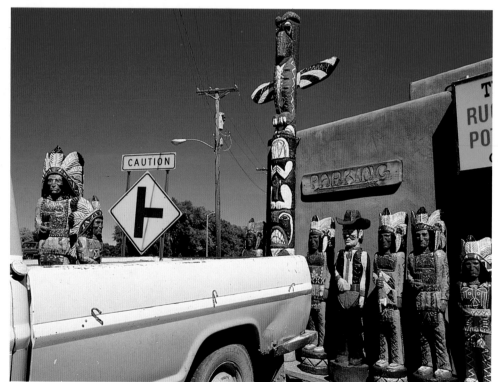

have inspired this migration to northern New Mexico, primarily to Santa Fe, but to Taos as well. Between 1970 and 1990, the population of Santa Fe and environs grew sixty percent. Today, there are 119,000 residents, half of whom live in the city limits. Many have homes elsewhere as well.

For realtors, the bloom stays on the rose. The "average" price of a home has doubled to $201,000 over the past five years. While few Hispanic families are fortunate enough to own valuable city property—the Martinezes are turning their 154 center-city acres, which they've owned for 200 years, into 115 lots—most locals are priced out of the housing market. Earning about $32,000 a year, local Hispanics can barely pay rising property taxes.

With bi-coastals able to afford rooms with a view, the controversy over affordable housing has, in fact, become one of politicians' and concerned citizens' biggest concerns. The "Aspenization" of Santa Fe has, in fact, engendered groups such as

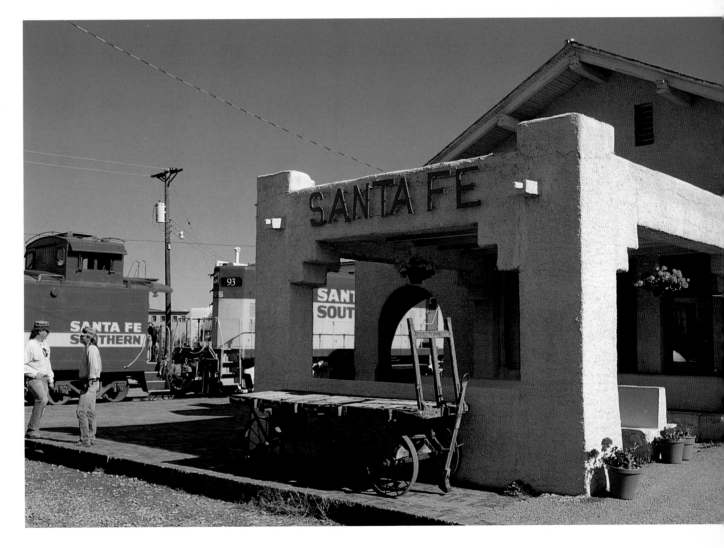

Chile *ristras* are hung up to dry. Tin-Nee-Ann Trading Company stops traffic with cigar-store Indians. A jackalope dresses up for tourists. And the railroad station never changes.

Santa Fe Tomorrow and SOS (Save Our Santa Fe) to confront problems and plan for the future.

The same issues confront residents of Taos, who wring their hands over a proposed major airport and several resort developments.

From a visitor's viewpoint, though, city problems are for residents, and summertime in Santa Fe is a time to enjoy the nearby out-of-doors river-rafting on the Chama; exploring Georgia O'Keeffe country around Abiquiu; horseback riding in the Pecos Wilderness. Back in town, there are numerous ways to satisfy the cerebral—take a workshop in trade beads, photography, or the history of the atomic bomb; visit the Museum of International Folk Art with its collection of ten thousand pieces from around the world donated by Alexander Girard; stand in front of canvases by members of the Santa Fe and Taos schools of art at the Museum of Fine Arts.

While there is widespread agreement that the city sadly lacks a top Indian art museum, scholars and summer visitors can certainly begin to learn the history of and be exposed to the beauty of Native American weaving, potting, beadwork, and painting at the Wheelwright, the School of American Research, the Museum of Indian Arts and Culture, and the Institute of American Indian Arts. The problem is that most of their collections remain out of sight, hidden from view in back rooms and basements.

When firewood is sold from the back of trucks, when chile *ristras* are strung like entrails beside kitchen doors, when the aspens turn gold, when pumpkins are piled up for sale in parking lots, when hotel rooms are available, when bluebirds head south and the night air begins to be filled with the fragrance of piñon fires, summer has ended. The good news is that the wonders and beauty of autumn, winter, and spring in Santa Fe are right behind.

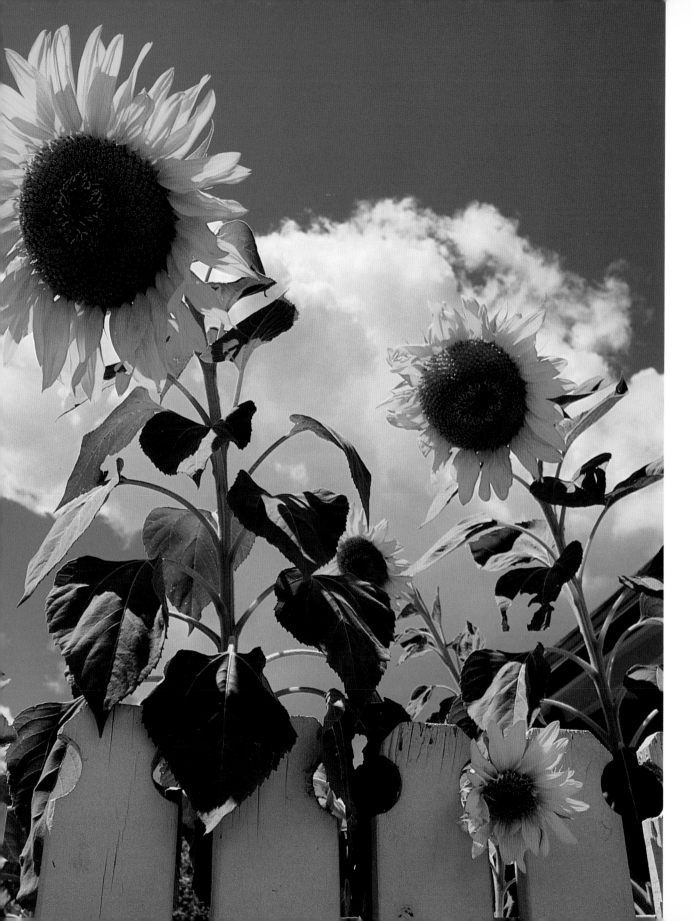

far left: An artist decorates the exterior of a Canyon Road window.

left: Sunflowers thrive in the summer in northern New Mexico, where days are warm and nights are cool.

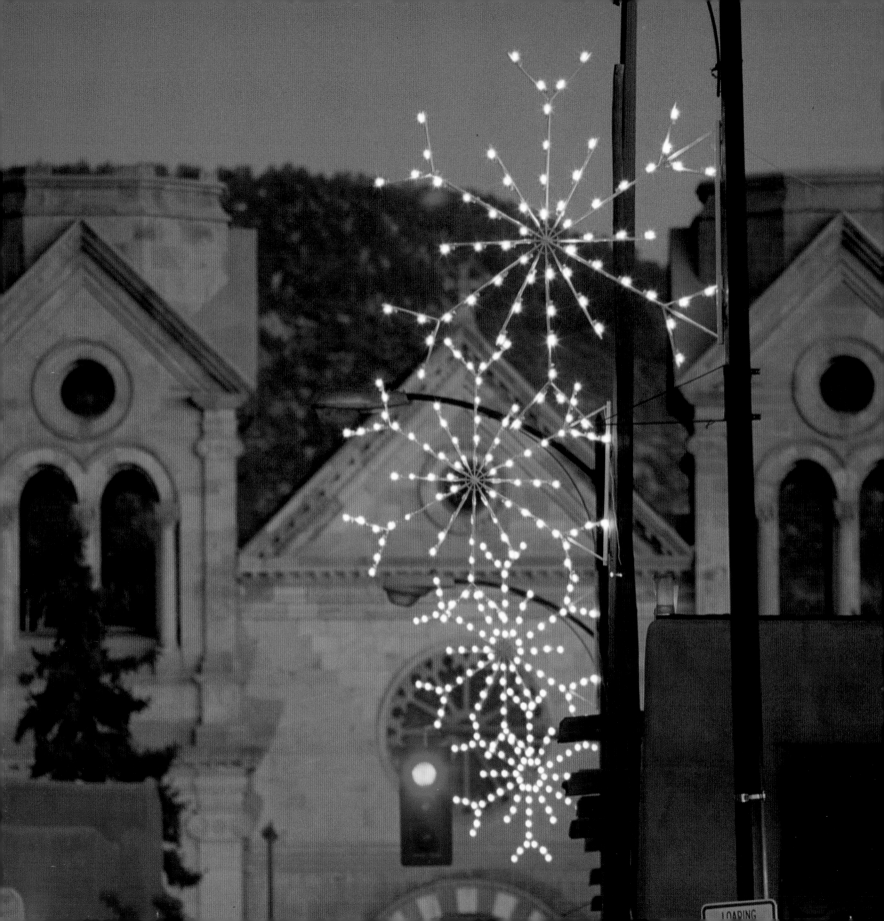

CHRISTMAS IN SANTA FE

 Early in the Santa Fe yuletide season, performances of Spanish miracle plays brought to the New World by priests over three hundred years ago are still performed. *Las Posadas* are performances reenacting the search by Joseph and Mary for a room in an inn (*posada*). The main performance takes place on the plaza; others take place in schools, neighborhoods, and small Spanish villages up in the mountains. ✹ The original performances, after moving out of the churches and onto the street as folk plays, were put on by roving troupes of actors. Early records show that in 1856, the plays moved throughout Santa Fe, then on to the neighboring villages of Tesuque, Nambe, Chupadero, and Aqua Fria. ✹ Other traditional Christmas performances include *Los Pastores*, the story of the three shepherds. With frequent off-color lines creeping in over the centuries with which to regale viewers, players—and spectators—today look on a performance of *Los Pastores* as a farce rather than a deeply religious

left: Christmas decorations give holiday cheer to the street in front of the Cathedral of St. Francis, built by Archbishop Jean Baptiste Lamy.

celebration of the search for the baby Jesus. *Los Tres Reyes Magos*, the tale of the three kings, continues to maintain its solemnity.

Plot lines in these plays have been handed down from father to son. Character parts—Bartolo, the lazy shepherd; Lucifer; San Miguel, the Archangel—are often played by the same person each year, usually with a touch of humor added to the sacred. "Oremos, oremos, del cielo venemos. Si no nos dan oremos, puertas y ventanas quebraremos," children sing in *Los Tres Reyes Magos*. "Praying, praying, we come from the heavens. If you don't give us alms, we'll break your windows and doors."

The pueblos also offer remarkable Christmastime opportunities to peer into the past. With the Christian Christmas season corresponding closely to the winter solstice observance in the Pueblo Indian religion, the dances are open to outsiders. The most frequently performed are the Buffalo Dance and Los Matachines. With both pueblo and Hispanic versions, the

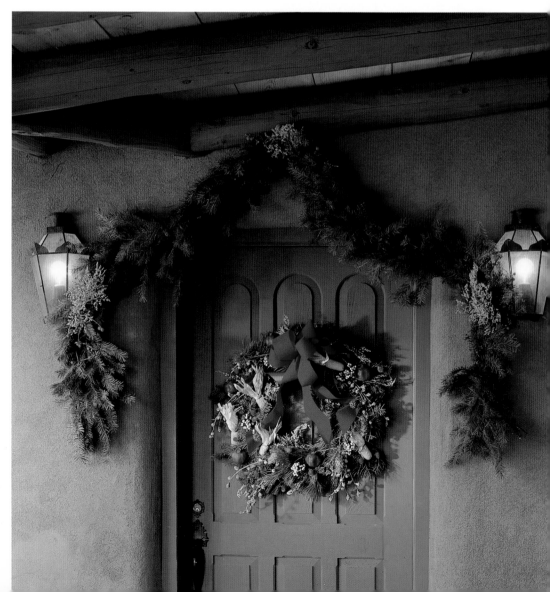

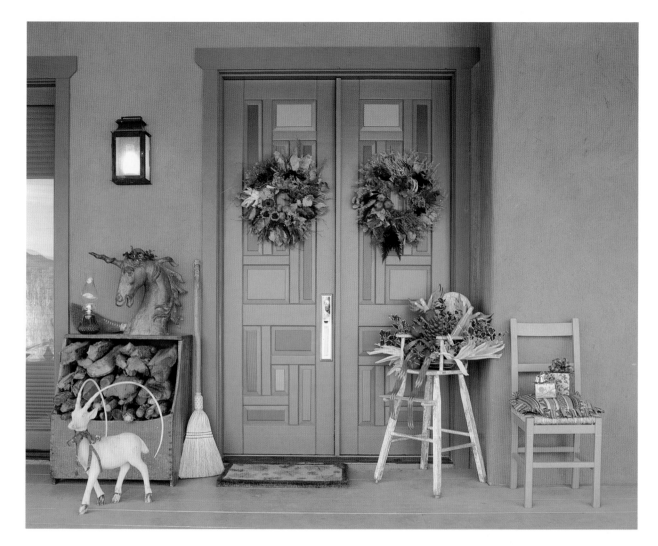

Christmas wreaths—
which frequently
include colorful dried
flowers and fruits—
are hung on doors
and windows
throughout Santa Fe.

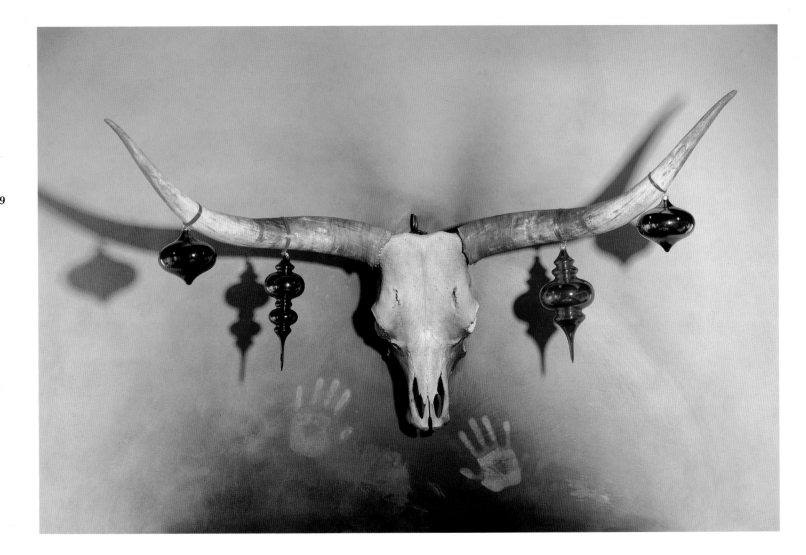

38 39

top: Dressed up for Christmas, a cow skull looks down on a much-used adobe fireplace.

right: A Mexican-style Christmas tree stands in front of a nineteenth-century hand-painted French screen.

latter dance deals with the conflict between good and evil and has several variations, the most common being Montezuma's conversion to Christianity.

What is the weather like in northern New Mexico in winter? It is often brighter and bluer than at other times. For most people, that's fine—unless, of course, you're hoping for a white Christmas. Fortunately, Santa Claus travels by sleigh, and he invariably has snow sent ahead to ensure a smooth landing.

On Christmas Eve, more likely than not, huge, dark clouds roll in from the north. By mid-afternoon, flakes begin to fall, first over the Sangre de Cristo mountains, then in town. Dark green piñon trees quickly become white. Adobe walls are frosted with icing. Like whipped cream on shortcake, dollops of snow cling precariously to the ends of *vigas*. Cars on the Paseo de Peralta begin to crawl. Skiers look with hopeful expectation at the Ski Basin and purr with anticipated downhill delight.

One inch, two inches, four inches, the snow continues to blanket the earth. Soon, Santa Fe is a gingerbread village with a powdered-sugar overcoat. A Southwestern stage set dressed for the holiday, the town boasts a cast of actors with a once-a-year performance. By dusk on Christmas Eve, the curtain is up. Always a sell out, white Christmas New Mexican style draws the crowds. Locals and visitors walk through the streets, collars up, mufflers tucked in. Once again, the Santa Fe Christmas show has begun.

Like lights on a proscenium, thousands of flickering *farolítos* line the sides of Canyon Road and the nearby streets of Don Gaspar, Acequia Madre, Garcia, and Delgado. All afternoon, home and gallery owners have been preparing the *farolítos*— small candles in paper bags with rolled-down tops, weighted with sand. Spaced about a foot apart, lining walls, roofs, alleys, driveways, and streets, the *farolítos'* candles flicker through the bags and throw

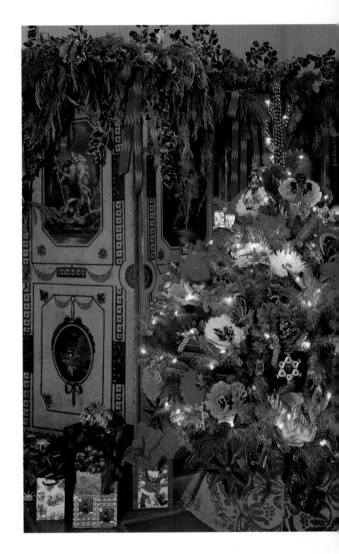

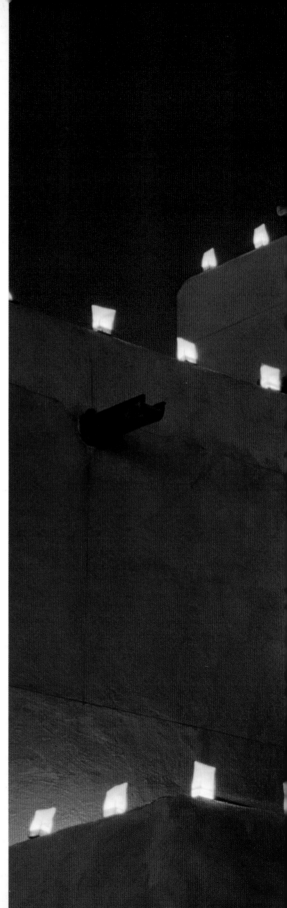

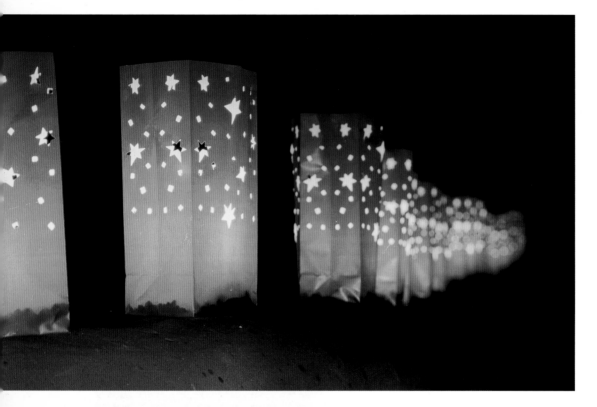

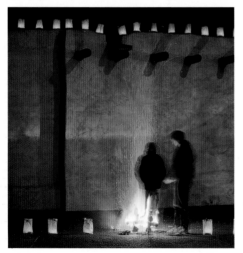

Lining walls, sidewalks, and rooftops with thousands of candlelit paper bags called *farolítos* is a **Christmas tradition in Santa Fe.**

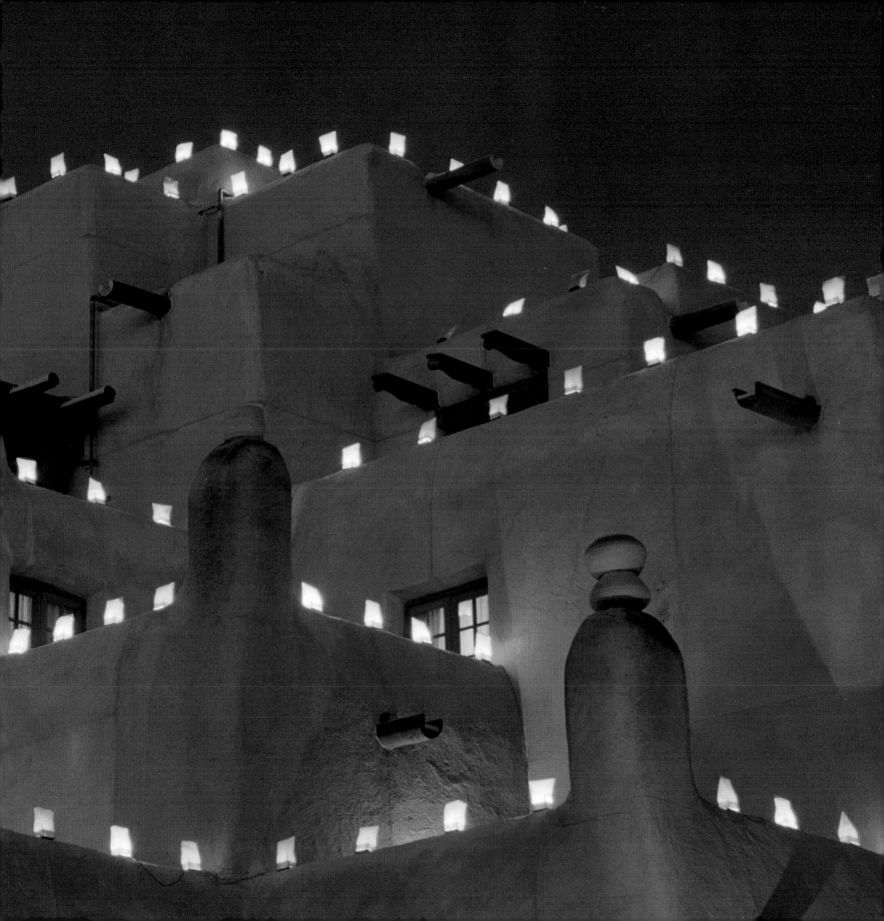

dancing shadows on the fresh fallen snow.

Snaking and curling along the edges of Santa Fe's highways and byways, the little lights have a long history. Legend has it that señoras of the nineteenth century saved the paper that fine china came in and turned it into lanterns to light the way on Christmas Eve for Santo Niño. Chinese paper lanterns that Spanish galleons brought to Mexico from the Orient were also brought north to New Mexico. They, too, helped to inspire the creation of the *farolíto*.

The *farolíto*'s expanded presence in Santa Fe started in 1872, when the square-bottomed paper bag was patented in Boston. The paper shortage solved, citizens could light *farolítos* by the hundreds, and they did so. Today, they are lit by the thousands on Christmas Eve in Santa Fe and throughout New Mexico. Residents of Española, forty-five minutes north of Santa Fe, boast that they light forty thousand *farolítos* on December 24th—both in town and along the highway in and out of town.

Joining the *farolítos* along the streets, alleyways and courtyards are blazing *luminarias* (bonfires) of *ocote*, pitch pine sticks, crisscrossed in a stack.

Electrolitos (electrified paper bags) and *ristralitos* (electrified *ristras*) are twentieth-century time-savers that horrify traditionalists—with very good reason!

Merrymakers are invited inside homes—the front doors of which are frequently decorated with red chile Christmas wreaths—to drink hot cider and nibble on traditional sugar cookies (*biscochitos*). After introducing themselves to their hosts and one another, they join together to sing "Silent Night" and "Oh, Little Town of Bethlehem."

By ten o'clock, the *farolítos* and the *luminarias* have burned down. An occasional candle has tipped over and a paper bag has gone up in flames. Slowly, the crowds thin out. Church bells begin to ring. The faithful continue on to mass to fall on their knees. The less devout return home to fall into bed.

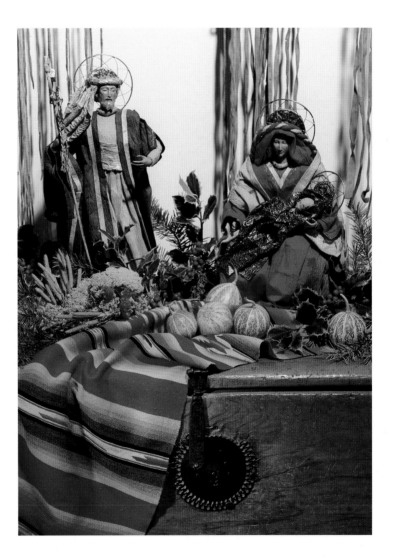

Reverence and whimsy join hands at Christmas when Anglo, Indian, Hispanic, and Mexican holiday decorations make their appearance.

INDIAN AND SPANISH MARKETS IN SANTA FE

 If there needs to be a special incentive to come to Santa Fe, the City Different offers a multiplicity of enticing year-round choices. Music lovers from throughout the United States and Europe come for the summer sessions of the Santa Fe Opera and the Chamber Music Festival. "Foodies" book ahead—any month—to try the city's numerous Southwestern and Tex Mex restaurants. Skiers head up, then down, the mountainsides all winter. ❋ There are two very special annual events as well. They are marked on calendars across the country months ahead. Visitors by the thousands fly into Albuquerque to drive an hour and a half north to Santa Fe to buy *santos* and other carvings at Spanish Market in late July. Another migration of shoppers shows up at Indian Market in mid-August, when there's a mad rush for pots, jewelry, and beadwork. ❋ Both markets offer a rare opportunity to artists. In a city with hundreds of galleries, the two markets provide a unique chance for artists to sell directly to the

left: At Indian Market in August, local Native Americans sell their handicrafts to thousands of out-of-town visitors. Beadwork typically brings a high price.

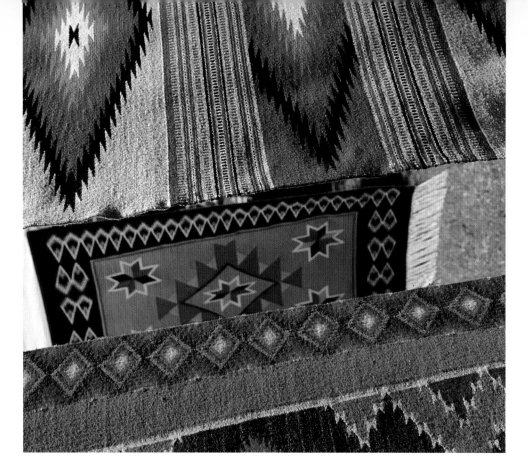

top: Handwoven wool rugs, frequently decorated with acrylic dyes, catch the buyer's eye.

bottom: Among the traditional items for sale at the July Spanish Market, straw appliqué crucifixes win First Place.

right: Tin work is a long-standing Hispanic specialty. Here, religion and craftsmanship combine to create images of saints.

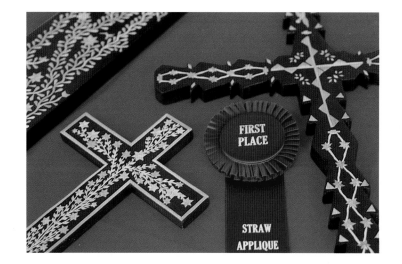

public. With no middlemen, there are bigger profits. Spurred by the economic incentive as well as the pride of craftsmanship, exhibitors put up hundreds of booths in and around the plaza.

An additional feature at both markets is that many items offered for sale have been entered in a judging contest. Here is a chance for hardworking participants to be recognized publicly for the hours and months that go into their work. A blue or red ribbon can add immeasurably to one's pricing.

For centuries, Native Americans produced pots to draw water with, to cook in, and to eat from. They were often beautifully made with compelling decorations. Artisans also made wonderful jewelry, did handsome beadwork, and wove remarkably colorful blankets. Then came the railroads, bringing in carloads of inexpensive mass-produced goods. Crafting suffered. Native Americans saw no reason to work for hours making something if they could buy it at the general store for very little money.

Fred Harvey, a transplanted Englishman, helped to reverse the tide. He added souvenir stores to his chain of railroad station restaurants and hotels throughout the Southwest. Native Americans were commissioned to return to their looms and potters' wheels to produce inventory for his shelves. Introduced to jewelry making by wandering Mexican and Spanish silversmiths in the mid-1800s, Navajos were especially adept at silver and turquoise jewelry, concha belts in particular.

Still, the quality wasn't really there. Not like it had been. Enter two remarkable women. Newcomers to Santa Fe Rose Duncan from Indiana and Vera von Blumenthal from Russia decided to do something about the situation. In 1917, they began to teach the women potters at San Ildefonso pueblo what their ancestors had known—how to make quality pots. The focus on higher quality carried over into other crafts as well as to other pueblos.

The two women's success at instilling a sense of pride in Native Americans for their workmanship was great enough that Edgar Hewett, director of the Museum of New Mexico in Santa Fe, entered the picture. He realized that a public showcase was important to maintain the craft momentum and to introduce the buying public to the renaissance in quality Indian workmanship.

In 1922, he invited Native Americans

from throughout the United States to show their wares at the Santa Fe state armory. The best-tasting home-grown chile and the best-looking baby were among the categories for prizes. For crafts, the first prize was $5; second prize was a munificent $2. Big bucks way back then.

Camping on the lawn outside the courthouse, Indians from tribes throughout the nation brought incredible items. Dakota Sioux showed priceless heirloom beadwork. Apache and Navajos arrived with basketry and weaving never before shown in public. The *New Mexican* magazine immediately paid homage in a September 6, 1922, issue: ". . . [Indians] are a marvelous people . . . their art is unique, absolutely distinctive; there is nothing like it in the world; it is a genius for decoration unequalled by any nation of people . . .

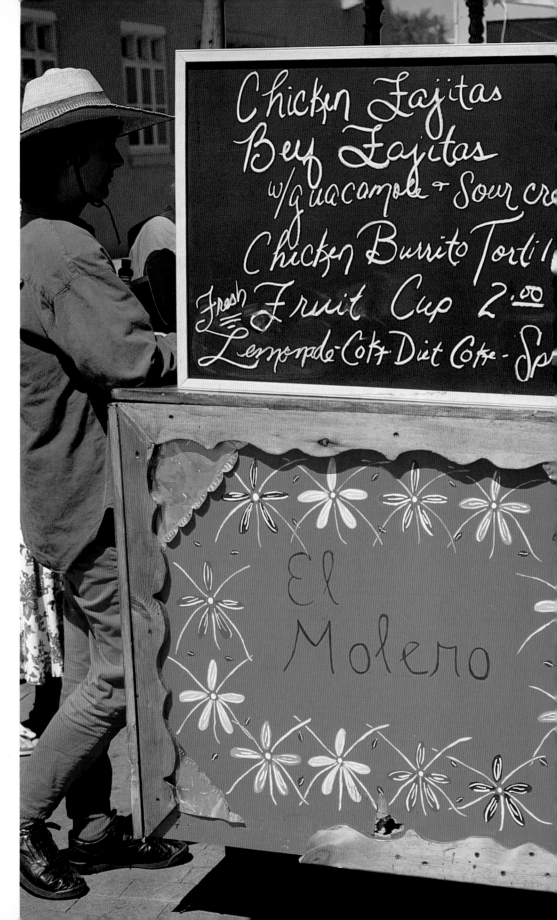

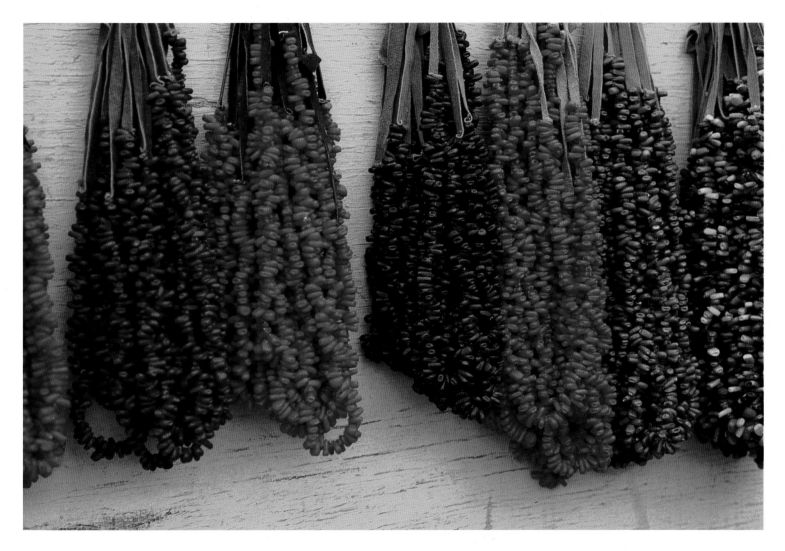

left: Hungry shop-
pers line up at a
Santa Fe street
vendor to choose

from a menu of typ-
ical Southwestern
cuisine.

top: Necklaces
made of brightly
colored dyed corn
are among the

many tempting
handicrafts for sale
at Indian Market.

this art is one of the world's greatest treasures; it is a priceless possession of America, and America is to be proud."

Hewett, on the other hand, had written that "it is not expected that the initial efforts (of Indian Market) will be productive of anything spectacular." He was proven wrong. Moving into the patio and under the portal of the Palace of the Governors, the exhibitors grew in number each year. So did the recognition of the need for a permanent organization to help Indians with their lives, including the continued nurturing of their exceptional creative skills. In 1933, the Southwestern Association of Indian Affairs (SWAIA) was started. Among its long-standing, multidirected interests in Native Americans has been the administration of the annual Indian Market.

Today, Indian Market is the largest American Indian art exhibit and sale in the world, with more than 450 exhibition booths on and around the plaza in Santa Fe. Over one thousand Indians from at least one hundred tribes offer for sale items that fit into 250 categories of artwork. On the Friday night before the market begins on Saturday morning, judges select winners from fifteen hundred items entered for approximately $40,000 in prize money. The next morning, the stampede begins at 8 A.M. For three days, anywhere from one hundred thousand to two hundred thousand serious buyers and lookers push and shove their way up to the displays of pottery, jewelry, and other items for sale.

With an estimated $135 million exchanging hands during Indian Market, the rush to buy what is for sale at booths of the

best-known artists is frequently over by 8:05 A.M. Holding back their best work for Indian Market, the nation's leading Native American artists are inevitably sold out within minutes of the event's official opening.

Sharp buyers, many from abroad, prowl the booths to look for the rising stars. Way back in 1924, San Ildefonso potter Maria Martinez had the chutzpah to sign her pots. No Native American had ever done that before. Today, everything that Martinez made is sought by museums or private collections.

In 1949, another ceramist made her debut: Helen Cordero introduced her first storyteller doll. Painted orange, black and white, their heads tilted back, mouths wide open, eyes closed, the storytellers were covered with small children clinging

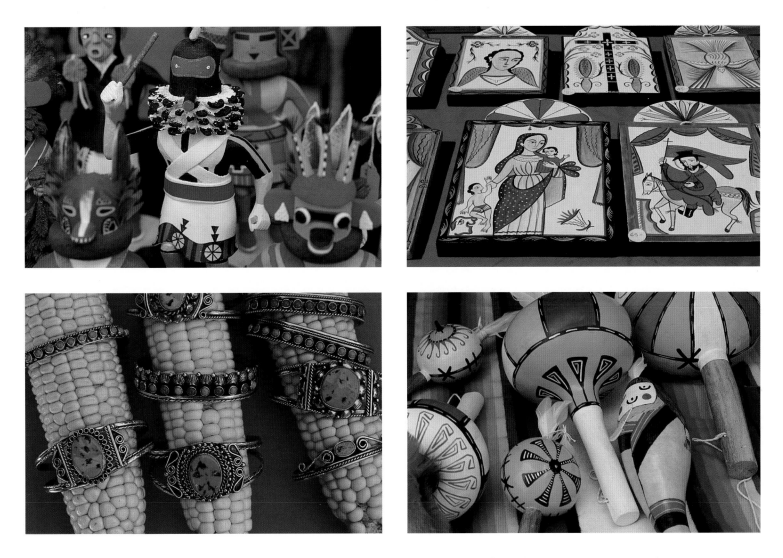

At Indian Market, buyers rush to the stalls to buy kachinas, rattles, and jewelry—all of which have been authenticated beforehand as true native handicrafts. Native American velvet skirts are also popular among buyers.

to the storyteller's arms, legs, and back. As with Martinez, Cordero's work is sought today by museum curators and collectors nationwide.

A unique aspect of Indian Market is SWAIA's insistence that its rules be maintained to ensure the quality of each crafter's items for sale. Inspectors patrol the booths to be sure that no commercial materials are used in anything for sale; that no imported, non-Indian, or entirely commercially manufactured items are for sale; and that all items for sale in the booth are made by the vendor. All selling must be transacted by the artists and/or members of the artist's direct family.

SWAIA makes certain that cultural identity is also maintained. A Navajo, for instance, cannot submit a kachina carved in the Hopi fashion, nor can a Hopi submit jewelry made in the Navajo fashion.

Founded in 1925, the Spanish Colonial Arts Society recognized the need to preserve New Mexico's centuries-old

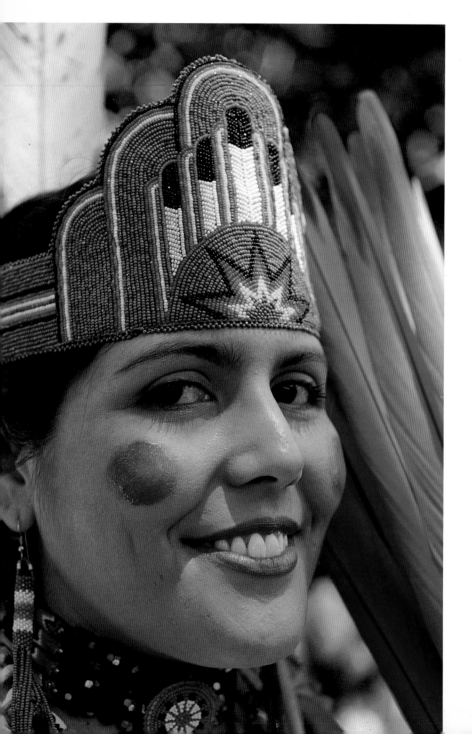

left: In 1994, Tony Veryackwe, a Comanche from Anadarko, Oklahoma, won Second Place in the Plains Tribal Dress contest at Indian Market.

right: At Hispanic Market, the Virgin of Guadalupe is a popular image on handpainted *retablos* (religious icons).

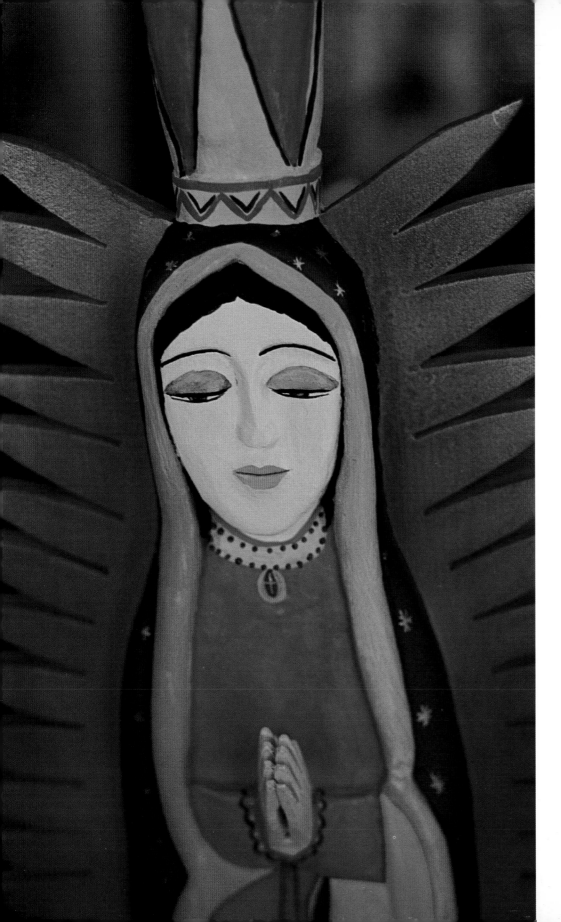

Hispanic craft tradition. It was not until 1951, however, when the society began to oversee Spanish Market, that there was an official annual opportunity for more than two hundred Hispanic exhibitors—many of whose ancestors arrived in the sixteenth century—to set up booths to sell their father-to-son handicrafts around the plaza.

At the annual Spanish Market in July, there is no problem of cross-cultural merchandising. Having had their work screened according to traditional artistic criteria set up by the Spanish Colonial Arts Society, exhibitors are required to be at least a quarter Hispanic and to have been born either in New Mexico or Colorado. With similar historic roots, whether the artist comes from Truchas, Cuba, Ojo Caliente, or Española, vendors offer *santos* (carved wooden statues of saints); weavings; furniture; tinwork; *ramilletes* (paper garlands); and straw appliquéd items.

Of all the items for sale around the

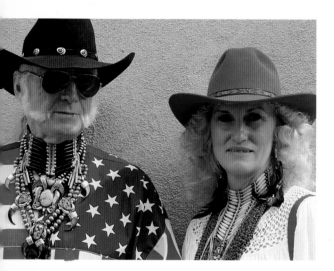

At both Indian and Spanish Markets, buyers and vendors alike are proud of their skills. For Anglos, it can be the art of dressing up; for Native Americans, their pottery; for Hispanics, their carved crucifixes.

plaza at Spanish Market, the *santos* have the most historic and contemporary meaning. The wooden statues are carved by *santeros* (male carvers) and, yes, by *santeras* (female carvers), who are increasing in number. With a collection of over twenty-five hundred Hispanic artifacts dating from the 1500s, a 1993 exhibition of contemporary New Mexican *santeras* at the International Folk Art Museum showed the work of twenty-six women. In addition, many of the exhibitors showed brightly painted *bultos*, three-dimensional sculpture that includes *santos*. The carvings are occasionally also left unpainted to show the grain of the wood.

Many carvers who display at Spanish Market come from Cordova, a mountain village north of Santa Fe famous for its artisans. While each artist has his or her own distinct style, the *santos* continue to have a painstaking iconography—St. Joseph always carries his staff, rays of light always surround Our Lady of Guadalupe. Often the fifth or sixth generation in a family to specialize in the craft, the individual carvers straddle the need to keep to tradition and the desire to let their own distinctive light shine through the works they create.

For some Hispanics, the demands of Spanish Market are too stringent; therefore, they show at the competing, nonconformist Contemporary Market held at the same time nearby. There, they explore alternative mediums and colors.

The origins of all Hispanic crafts can be traced to Spanish settlers in New Mexico who brought religious objects with them from Mexico. As the population

grew, so did the demand. Local carvers at first copied Mexican images, but soon they began to sell their own unique adaptations. Today, the more folksy New Mexican–style *santos*, past and present, are sought by collectors and museums nationwide. The Gene Autry Western Heritage Museum in Los Angeles, the Smithsonian in Washington, D.C., and the Heard Museum in Phoenix all include contemporary New Mexican folk art.

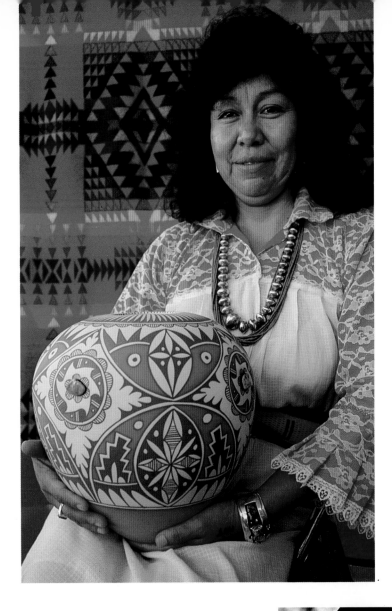

To walk among the booths at either Indian Market or Spanish Market is to step back into history. For scores of years, rendezvous and trade fairs were held in northern New Mexico where Hispanics, Indians, and Anglos put up their wares and put down their guns. Today, Hispanics and Indians continue the tradition. Who knows, Anglo Market may be next.

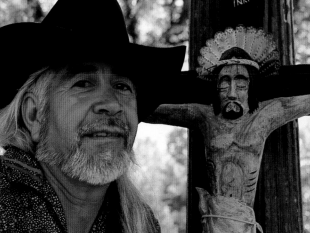

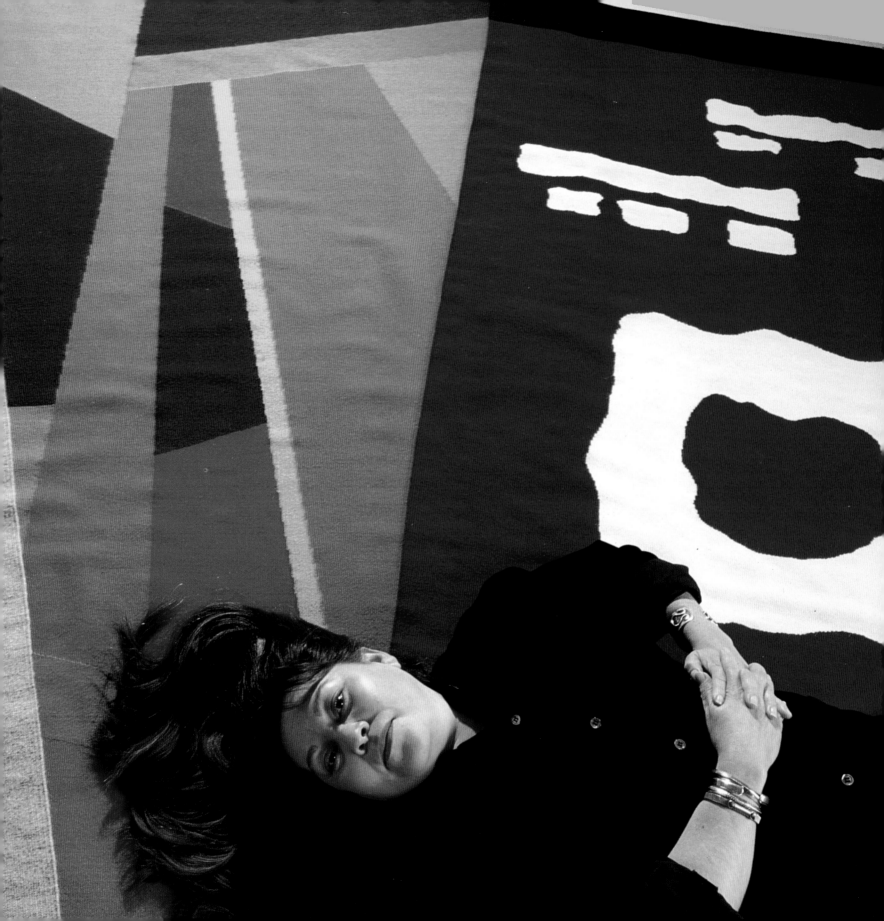

LEFT BANK OF THE SOUTHWEST

 Of all the descriptions of Santa Fe and Taos, the Left Bank of America is among the most accurate. For centuries, Native American pueblo dwellers produced art in the form of utilitarian pots, baskets, and jewelry. Later, Hispanics added to the eighteenth- and nineteenth-century art scene with their carved and painted religious handicrafts. The traditional, deep-felt, soulful qualities behind the inspirational creations of these two New Mexican cultures have brought unique spiritual resonance to many early Southwest treasures. ❋ It wasn't until the late nineteenth and early twentieth centuries, however, that northern New Mexico gained its Anglo recognition as a magical source of artistic inspiration. Through word-of-mouth advertising and reasonably easy access by railroad, the two towns began to evolve into the seventh arrondissement of America. While Fitzgerald, Picasso, Dos Passos, Hemingway, and Stein made waves on the other side of the Atlantic, a cadre of fellow

left: Native American Ramona Sakiestewa weaves in the Pueblo and Navajo tradition. Self-taught on the vertical loom, she began to weave when she was seventeen years old.

Americans—artists primarily—rode the tide in the United States to the Great Southwest.

Unlike turn-of-the-century artists' colonies in Normandy, Brittany, and on the East Coast of the United States—including Woodstock, Cos Cob, Ogunguit, Cape Ann, Provincetown, and New Hope—Santa Fe and Taos provided fresh, exciting, and untapped imagery of High Country beauty in the isolated and unrecorded northern New Mexican countryside. Bored with the déjà vu of European and New England landscapes, of peasants and architecture, adventurous painters went West to fill their canvases with strong, colorful, unknown landscapes, and with the romance of the Hispanic and Indian cultures.

In a letter to a friend, Helen Blumen-schein, painter and wife of fellow artist Ernest Blumenschein, offered a reason for the artists' Westward Ho. "We were ennuied with the hackneyed subject matter of thousands of painters: windmills in Dutch landscapes; Brittany peasants with sabots; French roads lined with Normandy poplars; lady in negligee reclining on a sumptuous divan; lady gazing in a mirror; lady powdering her nose; etc. We felt the need of stimulating subjects."

Galleries were equally enthusiastic. Nationwide, they hung the canvases sent them by artists living in remote New Mexico. Savvy collectors responded as well.

Before long, the Taos and Santa Fe schools were established. The migration west of the Hudson and east of the Sierras continues. Today, hundreds of serious artists and Sunday painters have settled down to work in Santa Fe and Taos. Many stay year round, others come for periods of time. The major change in the cast of creative characters is the expansion of expression and the international recognition that traditional Indian and Hispanic handicrafts are really art. Nowadays, Santa Fe and Taos both are full of people from every creative medium, including writers, poets, photographers, ceramists, songwriters, editors, playwrights, actors, musicians, weavers, and jewelers.

At the end of the nineteenth century and in the early twentieth century, Santa Fe's and Taos's trading posts and general stores were the predominant sources of anything for sale—including anything artistic. The infrequent tourists that passed through had few stores to visit and therefore precious little to buy. Hispanic

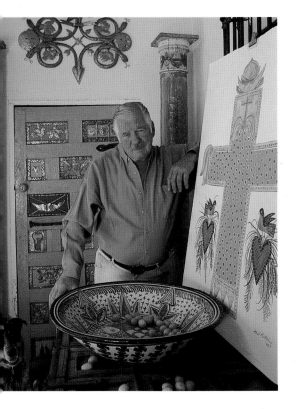

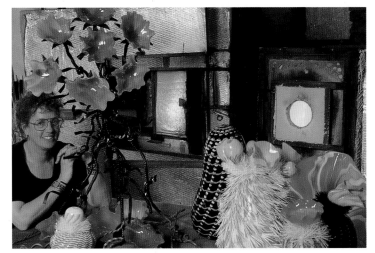

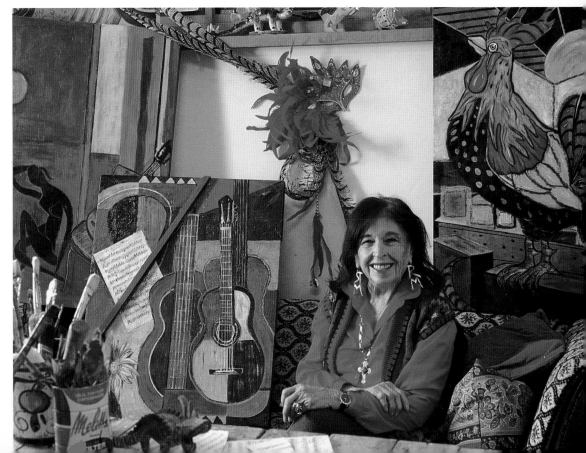

top left: Artist Ford
Ruthling.

top right: Glass-
blower Flo Perkins.

bottom right:
Artist Rosalea
Murphy. Since the
l920s, Santa Fe
and Taos have
attracted artists
of all persuasions.

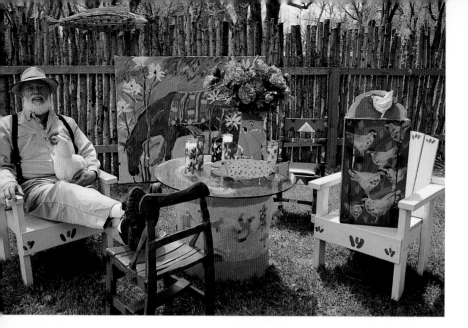

Taos artist Jim Wagner is known for his whimsical furniture and paintings. Artist Carol Anthony paints in Santa Fe and abroad. Like many New Mexican artists, they sell their pieces worldwide.

folk art and Indian crafts were the main things available. There were few paintings. Artists, for the most part, sent their canvases to dealers elsewhere or sold them directly from their homes.

Suddenly, the 1970s arrived and the picture changed dramatically. Discovered by the media after four hundred years of out-of-sight, out-of-mind oblivion and hyped relentlessly in every major magazine and newspaper, Santa Fe and Taos found themselves superstars short of hotels, lacking in restaurants, and ideal for retail.

With cash in their pockets during the affluent 1970s, 1980s, and early 1990s, more than a million and a half annual visitors to the two towns began to prowl the streets in pursuit of paintings, pots, and jewelry. Jean Seth opened her Canyon Road gallery in Santa Fe, garnered a stable of artists, and became the first really big-time operator in what was to become a very large art scene.

Today, Santa Fe's annual gross volume of art and art-related sales exceeds a staggering $200 million a year, according to a recent city-sponsored Arts Impact Study. Add to that figure an equally monumental multi-million-dollar-a-year cash flow in Taos. Opening and closing with regularity, the five hundred–plus galleries in the Santa Fe–Taos area make it the third-largest artistic revenue producer in the United States (after New York City and Los Angeles).

There is a conspicuous artistic difference between what is for sale on the two coasts and in New Mexico, though. Unlike their colleagues in New York and Los Angeles, most New Mexican art dealers stick with the expected. Big sellers continue to include coyotes, horses, spurs, and saddles. Plus Native Americans—the "old school" continues to favor having them wear headdresses; the "new school" leans heavily toward sunglasses and motorcycles.

Fortunately, there is a small core of courageous galleries in both towns that

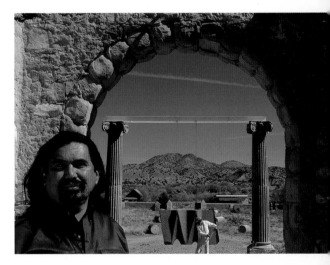

Works by granite sculptor Jesus Bautista Morales, who has a studio outside Santa Fe in Cerrillos, are in many museums and private collections. A new piece is hung between Greek columns.

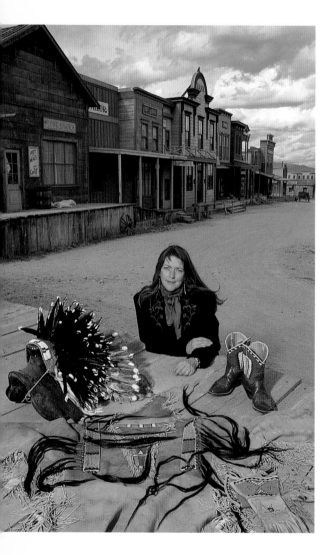

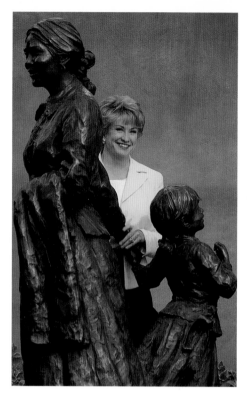

left: Cathy Smith
designs for films,
including *Dances
with Wolves.*

top: Sculptor
Glenna Goodacre
is known for her
Women's Vietnam
Memorial.

right: Customized
furniture and
doors by English
craftsman Jeremy
Morrelli are popular
worldwide.

shies away from the obvious to show the work of innovative national and international artists. Dependent mainly on serious collectors rather than walk-in tourist trade, these galleries are bright lights in an otherwise fairly murky art scene.

In 1995, Site Santa Fe may well have triggered a kind of regularly scheduled, Southwestern Biennial. Local, national, and global artists exhibited works throughout the town in a thematic exhibition entitled "Longing and Belonging: From the Faraway Nearby." Lectures addressed the interrelationship between local and global concerns of contemporary artists.

For the art student, Santa Fe offers another compelling reason to continue to the end of the trail. The ten-year-old Santa Fe Institute of Fine Arts has gained

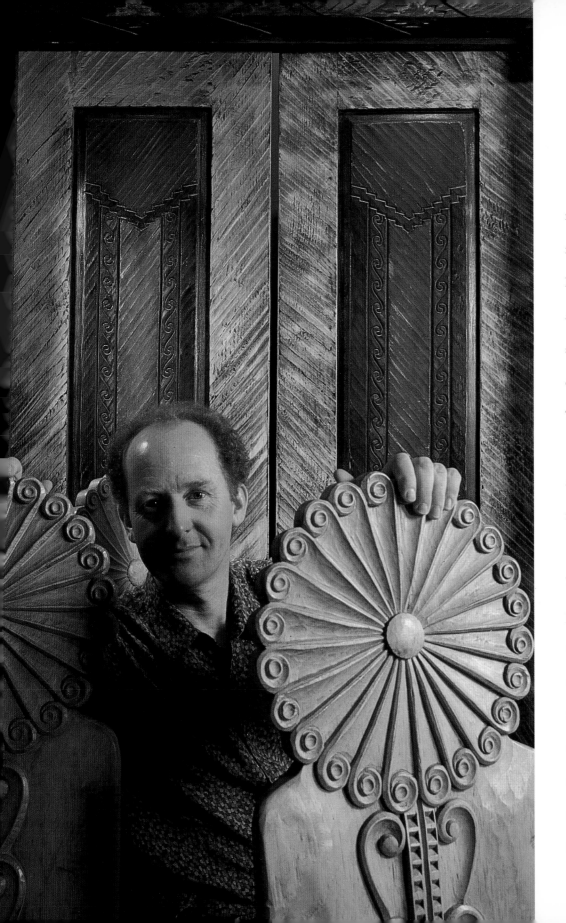

national recognition as a haven of academic encouragement. Year-round, month-long master workshops attract students anxious to study under the guidance of such national pacesetters as Helen Frankenthaler, Richard Deibenkorn, Wayne Thibaud, Larry Bell, and Nancy Graves.

For music lovers, the Santa Fe Opera and Chamber Music Festival are also summer excuses to roll into town.

Already in and around Santa Fe and Taos are scores of well-known creative people, many who live here year round, others who maintain homes here, as well as in Los Angeles and New York. With unlisted telephone numbers and beaten-up mail boxes, national big shots crave anonymity. Only a select few know the real estate whereabouts of producer Steven Spielberg; fashion model Lauren

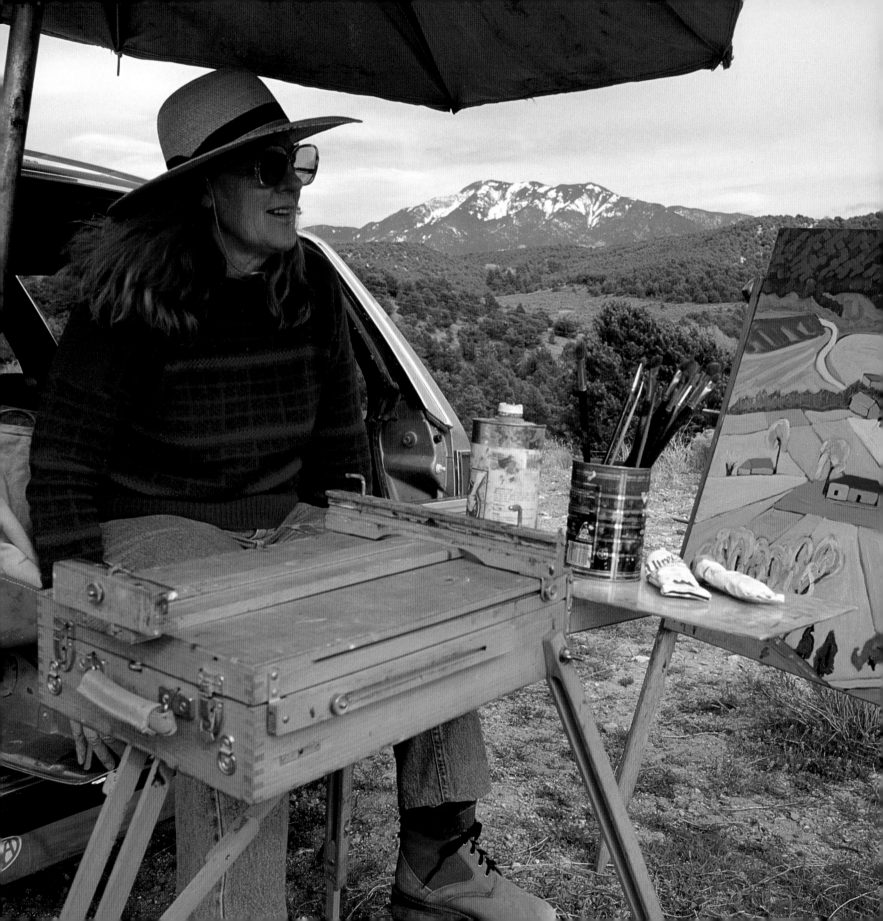

Hutton; songwriter and singer James Taylor; painters Agnes Martin, Armond Lara, Susan Rothenburg, and Bruce Nauman; sculptor Jesus Bautista Morales; talk show host Oprah Winfrey. Equally inconspicuous are photographers Herb Ritts and David Michael Kennedy; composer Dave Grusin; jewelry designer James Reid; actors Val Kilmer and Gene Hackman; comedian Carol Burnett; and actress Ali McGraw.

Why do Santa Fe and Taos still attract so many permanent newcomers? Possible reasons are to escape the growing problems of urban living; to be inspired by the infinite beauty of the landscape; to stand in awe of the endless flotillas of clouds by day; to be dazzled by the infinite twinklings of stars by night.

The reason for becoming a New

Mexican resident given by a former artistic "settler" to the Left Bank of America deserves repetition. Mabel Dodge Luhan, an early-twentieth-century expatriate, observed the draw of the Southwest and its subsequent transformation in one of her guests. "Take an exquisite sensitive mortal like Georgia O'Keeffe . . . and suddenly lift her from sea level to the higher vibrations of a place such as Taos and you will have the extraordinary picture of her making whoopee!"

Later, O'Keeffe confirmed her own lifelong love affair with her newfound artistic sanctuary. "If you ever go to New Mexico," she announced, "it will itch you for the rest of your life."

Walk around Santa Fe and Taos today, and you'll find a great many newcomers who are scratching very hard.

Alyce Frank (left) and Larry Bell (top) are among the many artists who live and work in Taos.

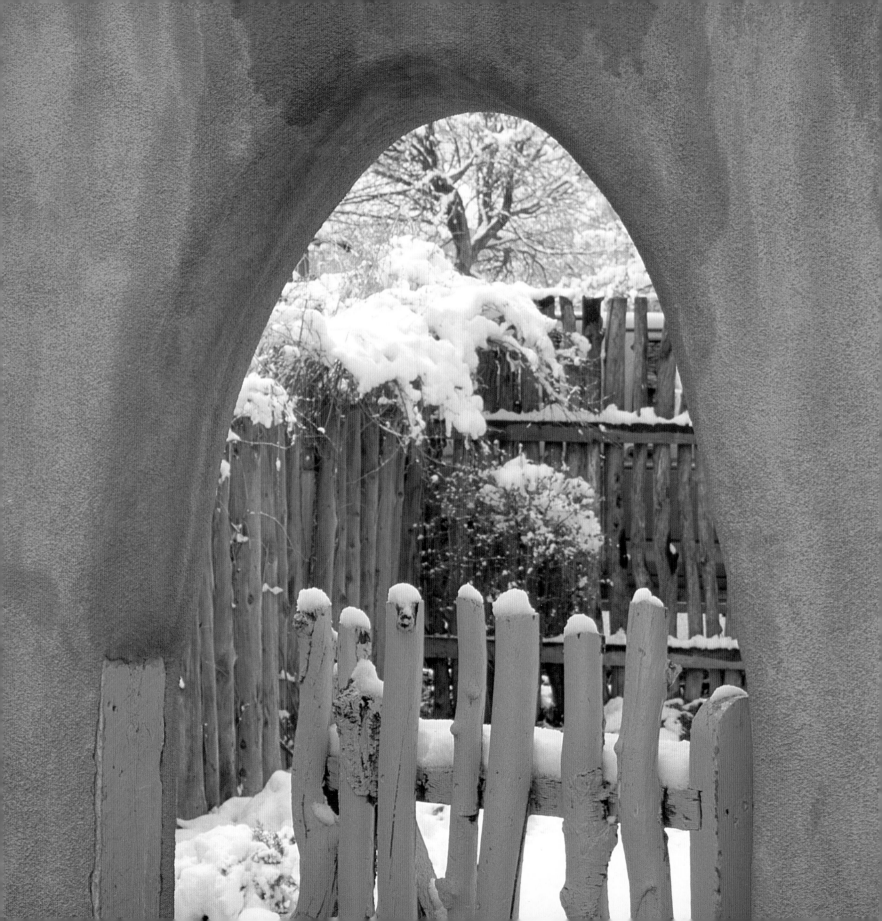

TAOS
WINTER

Snow in northern New Mexico is welcomed by native and non-native alike. Skiers stand by, poles in hand, ready to plummet down the mountainsides. Farmers look ahead to spring when the melting snow sinks deep into the earth to water the land. Artists bundle up, clear space in the drifts to set up their easels, and paint the villages and landscape. ❊ In Taos, with a population of roughly five thousand, the arrival of winter fills hotel rooms as rapidly as does the onslaught of summer travelers. At the base of the Sangre de Cristo mountains, on the edge of high desert along-side a dramatic, 650-foot-deep canyon carved out of the rock and soil by the Rio Grande, the town draws skiers from throughout the world—about seventy thousand a season. Few places in the United States, including many well-known Rocky Mountain resorts, can rival the town's average of 315 inches of some of the finest powder on the continent. Storms can dump up to over 550 inches of snow a

left: A longtime artists' colony with a year-round population of five thousand, Taos in winter attracts skiers from throughout the United States and from abroad, and in summer appeals to hikers and river rafters.

season in the Taos Ski Valley, resulting in a base of 100 inches or more.

With the same latitude as Algeria and Morocco, Taos also boasts some of the world's sunniest winter days. An additional lure is the low humidity—skiers experience minimal bone chill even when the temperature is low.

The founder of the Taos Ski Valley was Ernie Blake. A transplant from Europe, he and his wife had a mission. They wanted to start a Southwest ski resort, one that could rival any other in the world. After a state-by-state search, they settled on Taos. "Rhoda and I did it together; we were foolish as hell to go into the ski business . . . I didn't realize how big it would get and how much the financial involvement would grow . . . I knew I was going to get away from the Santa Fe syndrome . . .

people would come to Santa Fe, and they'd end up learning to do snowplow turns to the left, to the right; then they felt they were perfect. They would tell us that now, thanks to our efforts, they were ready to go to Aspen and to Sun Valley . . . That made me mad. I wanted to build an area that they wouldn't be able to handle after two days of weekend ski instruction."

Although early snows in some years would allow it to open in early November, the Taos Ski Valley patiently waits until Thanksgiving weekend to welcome skiers to its 12,000-foot-high Alpine slopes with a 2,600-foot vertical drop. For early arrivals, turkey and cranberry sauce are of secondary importance to being the first one down one of the area's seventy-one ski trails. With their wide variety of gullies and faces, chutes and steeps,

half of them are rated expert.

Entering the area through a five-thousand-foot-deep canyon that the Hondo River has carved out of the Sangre de Cristo mountains, skiers delight in the fact that Taos has yet to succumb to the over-commercialized frenzy that other resorts must cope with. Here, no more than 4,800 are permitted to christy down Twin Trees, Al's Run, or Highline Ridge, while up to 25,000 skiers a day often cause bumper-to-bumper traffic jams at other resorts over the border in neighboring Colorado.

For early Taoseños, fourteenth-century founders of the pueblo, winter was anything but a time to play. Rather, it was a season when they struggled to stay alive. Naming the settlement Place of the Red Willows, the Tiwa-speaking Indians,

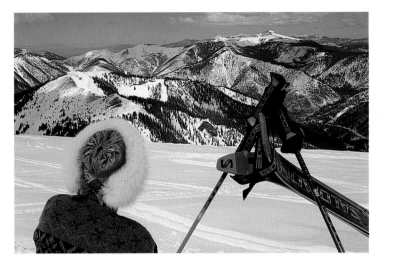

left: With an average of 315 inches of snow in winter, Taos boasts some of the finest powder skiing in the nation.

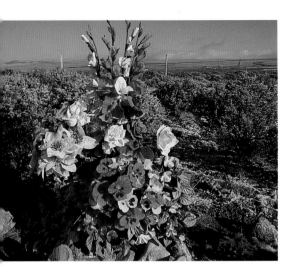

top: In New Mexico, the sites of automobile fatalities are marked with wooden crucifixes decorated with plastic flowers.

right: Farmers around Taos continue to raise livestock and struggle against encroaching residential development.

whose early ancestors arrived in the valley around A.D. 1000, huddled together around fires whenever they weren't out scrounging for food.

Today, winter visitors invariably begin the morning or end the day by sitting at an inn in front of a blazing fire in a kiva fireplace, drinking a cup of coffee or a mouth-puckering margarita, and digesting some local history.

Often attacked by Comanche warriors from the Plains, Taos Indians in 1540 faced a new problem when Spanish conquistadores entered the valley. In 1615, the old way of life was altered still more when the Spanish decided to settle down permanently around the pueblo. They named their main settlement Don Fernando de Taos; another one a few miles south they called Ranchos de Taos. Here, the San Francisco de Assis church, built between 1710 and 1750, still stands. It draws year-round visitors, thousands of whom delight in painting or photographing its dramatic

right: Like ocean waves, adobe walls appear to come in and go out like the tide. Upkeep is a constant consideration, however.

bottom: Blue is the color of New Mexico: the sky, gates, barn doors, windows . . . and delphinium.

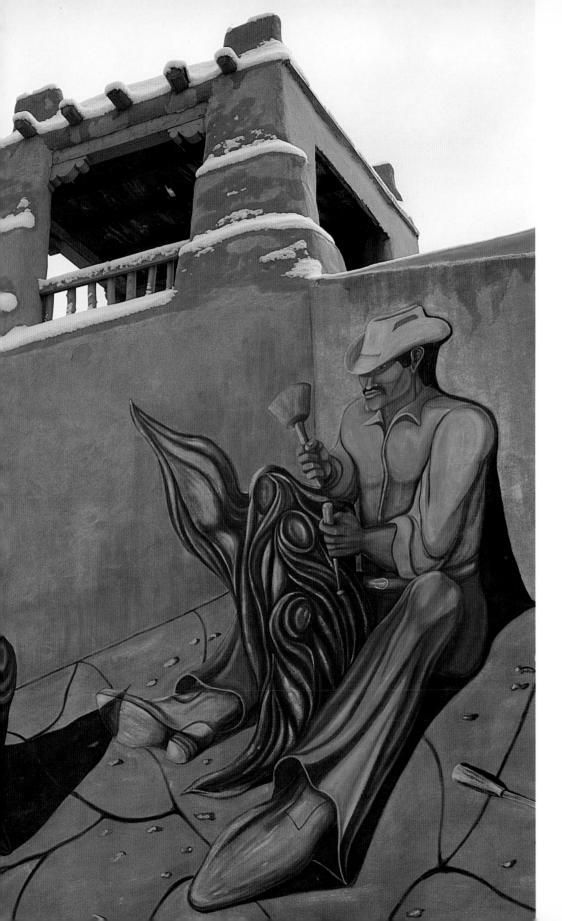

top: *Vigas* covered
with snow in the
morning is evidence
of an overnight
storm.

left: Woodworking
is a primary skill in
northern New
Mexico. Here, a wall
mural depicts a
carver at work.

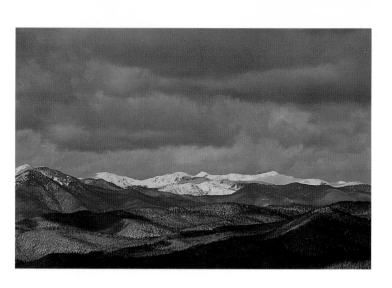

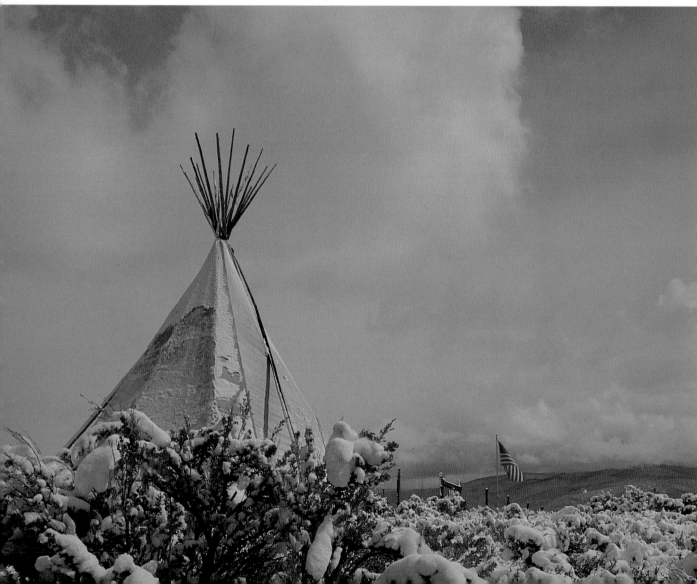

top left: **One of the oldest hotels in Taos, the La Fonda was a favorite of English novelist D. H. Lawrence.**

top: **By Thanksgiving, snowfalls begin to blanket the slopes of the Lower Rockies around Taos.**

left: **Covered with snow, a contemporary tepee is a reminder of the region's native history. By noon, there will be a cloudless, blue sky.**

exterior. After a winter snowstorm, the church's massive adobe buttresses look like monumental chocolate loaves covered with vanilla icing.

For the winter visitor to Taos, the snow-covered adobe structures along the town's frequently slippery, narrow streets and down its alleyways hint at the one-story, rambling adobe architecture that Kit Carson saw when he rode into Taos from Missouri in 1826 for the first time. A mountain man, Carson, along with other Americans, had ventured West as the frontier extended. They were joined by French trappers as well—men with names like Jeantete, Ledoux, Deteuis, Lontin, Clothier, and Lanadie. The annual Taos trade fair where Anglos and Indians bartered amicably was reason enough. The dividend was Taos light-ning, a homebrew of national repute.

With his wife, Josefa, Carson returned to settle permanently in Taos in 1843, becoming an Indian agent. He died in 1869; his gravestone is visible above the snow line in Kit Carson Park.

Outside of town, down some turn-of-the-century dirt roads covered with snow and lined with barbed wire glistening with ice, the Martinez Hacienda presents an insight into life in early Taos. Buttoning up against the cold, as penetrating inside the hacienda as outside, winter visitors enter what was really a small, totally self-sufficient town. Built around two *placitas* (interior courts), the twenty-one-room hacienda had a granary and a blacksmith shop. Sparsely furnished in early colonial style, the dwelling was the fortified com-pound of Don Antonio Severino Martinez, a well-to-do trader whose ox-drawn carts plied the trade route from Chihuahua, Mexico, to Taos. Fearful of raids by Plains Indians, Martinez, like other settlers, put no windows in his hacienda. All it took was one fatal arrow from the outside to kill someone on the inside.

The first serious wave of immigrants anxious to settle in Taos, in what was to become the Left Bank of America, did so soon after the summer of 1898, when artists Ernest Blumenschein and Bert Phillips were passing through the valley. Their intent was to go camping in Mexico, but a broken carriage wheel forced them to go into Taos to get it repaired. They fell in love at first sight with the settlement, with the area, with all northern New Mexico. The town's allure was so strong, in fact, that they didn't continue their journey.

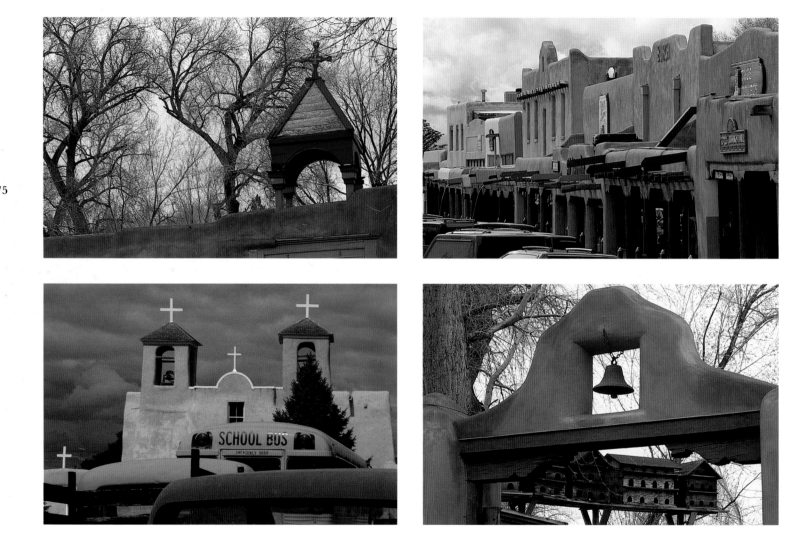

After visiting the seventeenth-century Ranchos de Taos **church and the plaza, visitors discover wonderful** **architectural embellishments throughout the town.**

Blumenschein and Phillips stayed. The former wrote a letter explaining why. "No artist had ever recorded the New Mexico I was now seeing. No writer had ever written down the smell of the air or the feel of the morning sky . . . [it] was the first great unforgettable inspiration of my life." The two converts urged other artists to follow in their footsteps. They did. Soon, canvas after canvas by early Taos painters E. Martin Hennings, Stuart Davis, Walter Ufer, Joseph Henry Sharp, Victor Higgins, and Emil Bisstram portrayed the strength and majesty of the land, the color and individuality of the people.

Winter, with its great drifts of snow covering the countryside and resting on adobe houses, was every bit as compelling to Taos painters as the same scene would be six months later when lilacs and fruit trees were in bloom. Then, there was the sky. A shimmery electric blue with flotillas of billowing clouds. The artists of the Taos School, like many of the Santa Fe School,

had lived and painted in Europe. Now they had discovered an unknown America, and they couldn't record it fast enough.

Displaying their canvases in gallery shows throughout the country—over eighteen Taos School exhibitions had been held in ten major United States cities by 1918—the artists were instrumental in drawing other expatriates to the area.

Commissioned also by the railroad to produce posters that depicted the Southwest in the most compelling manner, both Taos and Santa Fe painters found another way to add to their bank accounts.

Not every early "outsider" was an artist. One of the most flamboyant expatriates to settle in Taos was Mabel Dodge Luhan, who insisted that creative people were led to Taos, almost as if by magnetic force. "People . . . come to Taos almost as they had to. Impelled," she wrote in her own unique syntax. "Taos brings out the particularity in people. It is the most individuating place in the world, I think . . .

**Many streets in Taos
are named after
early French traders
and mountain men.**

Oh, yes! Taos does things to people . . . Some get it through the eye, some through the ear, and others through the pores of their skin."

The list of well-known people who "got it" included Lady Dorothy Brett, an early groupie from England who settled first in the shadows of D. H. Lawrence, then of Mabel Luhan. Brett's own remarkable paintings of Indian dances have since promoted her to being a force in her own right.

Winter, summer, spring, fall: Taos has a year-round indefinable, magnetic, and continuing counterculture sex appeal. For many, it is today what Santa Fe was yesterday. There is still a raw and muddy quality to Taos. The plaza is slightly down at the heels. Residents actually sit there and gossip, along with tourists who mix with the natives. There aren't many up-market restaurants. There are cafés where memorable coffee and homemade pie are still being served. There isn't a deli, but there's a food co-op. There's no symphony on Saturday night, but there is line dancing at Martinez Dance Hall. Taos is an unpretentious town of tenth-generation Hispanics, soul-searching Anglos, and Tiwa-speaking Native Americans who prefer to stick to their pueblo. There's talk of a jet port and a $40 million golf resort with three hundred houses. There are countless meetings to discuss the future, but very few to analyze the past.

Truth is, Taos hasn't really changed too much. The old girl looks especially good when the moon is full and fresh snow has fallen and filled in the centuries-old chinks and cracks in her adobe walls.

Way in the distance, up on the mountainside, a pack of coyotes joins together in a chorus of hair-raising howls. Throats outstretched, their jaws open to the wind and the snowflakes, they let out a crescendo of wails. Covers are drawn higher on winter nights like these. And if you listen really hard, the voice of Mabel Dodge Luhan lingers in the land. "The altitude upon which many slips of conduct are blamed is over 7,500," she wrote. "Sometimes an impatient native pushes his wife down a well, or a jealous sweetheart conceals a stick of dynamite in her rival's stove. 'Don't let the altitude get you,' we say to each other."

Old-timers throughout the West said something different, "Adios, see you in Taos." Today, a lot of newcomers are thinking the same thing.

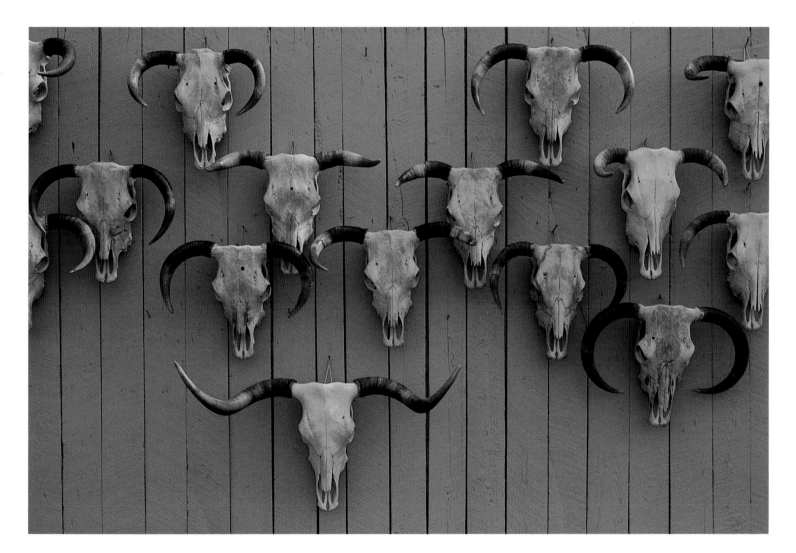

New Mexican
painter Georgia
O'Keeffe included
a cow skull in
many paintings.
Today, skulls are
for sale everywhere
in Taos.

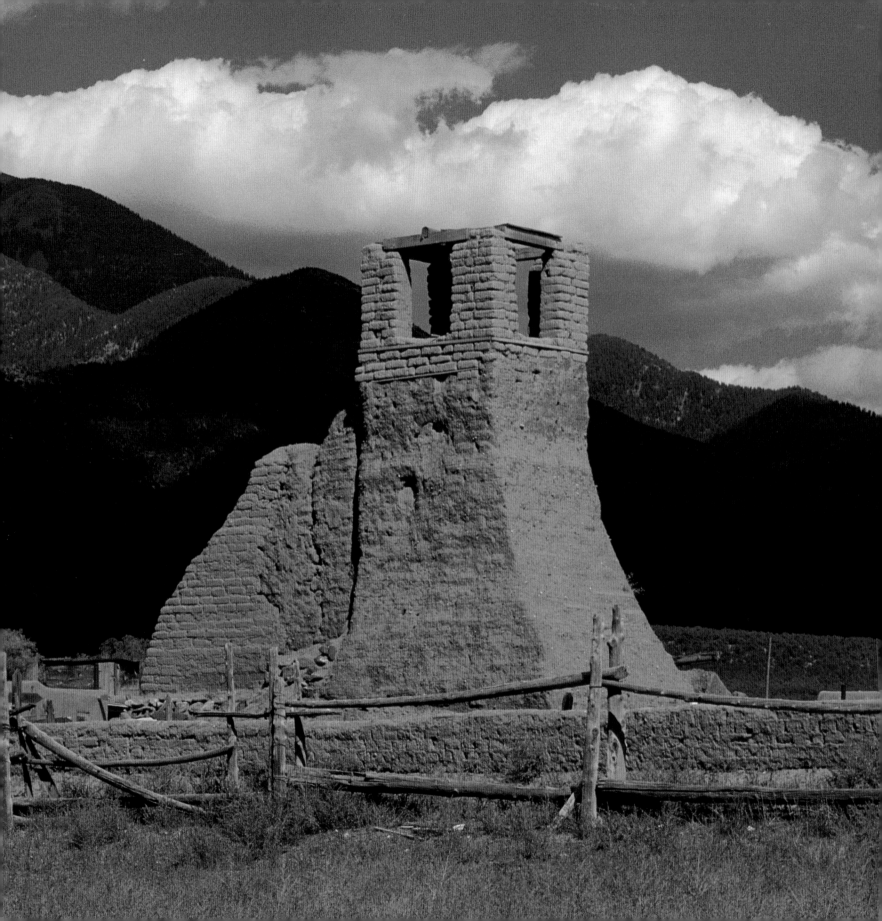

TAOS PUEBLO

 The Taos pueblo is the only classified World Heritage Site in the United States. With shards found at the pueblo dating from A.D. 1300, it was discovered to have been an active community of Indians when Europe was struggling through the Middle Ages and America was still undiscovered. ✹ Thought to be descendants of Asians who crossed a land bridge that spanned the Bering Strait from Siberia, current-day inhabitants of the pueblo settled there after being forced by drought to abandon their dwellings at Mesa Verde in today's Colorado. Over three hundred archeological sites in the Taos valley reveal that these early arrivals found the water they were looking for and spread out over the land. ✹ The primary settlement, however, was the pueblo. Legend has it that an early chief was led by an eagle to a sparkling stream at the foot of the mountains. The eagle then dropped two feathers, one on either side of the stream. The chief recognized the message. He ordered the

left: The ruins of the original San Geronimo Mission—destroyed in a pueblo revolt in 1847—guard the entrance to the Taos pueblo.

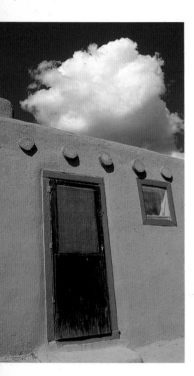

construction of the pueblo on both sides of the stream, a separation that continues to this day and allows a kind of two-team friendly rivalry between inhabitants.

The oldest indigenous architecture in the United States, the original rectangular Taos pueblo buildings were constructed of stone covered with mud. Today, they are all adobe, the Indians having learned about adobe construction from the Spanish. The buildings were, and still are, multistoried, the highest today being four levels with twelve rooms inside. Maximum security against invaders required early inhabitants to climb up ladders to enter the windowless buildings through doors in the middle of the tiered roofs. Defense walls and watch-towers were also a part of the early pueblo.

Today's less-hazardous times have allowed ground-floor windows and doors to

Doors and windows are painted bright colors throughout the Taos pueblo. The oven at the right, called a *horno*, is for baking bread.

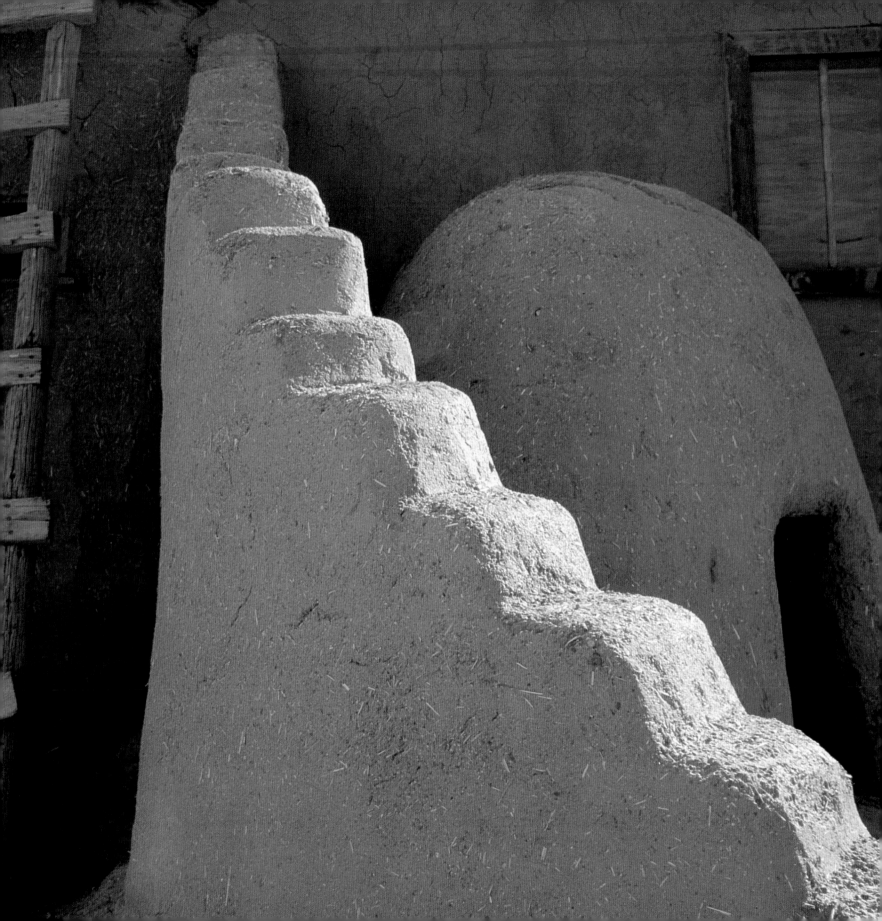

bottom: Visitors must pay an admission fee to enter the 400-year-old Taos pueblo.

right: A stars-and-stripes skull is for sale in one of the many pueblo shops.

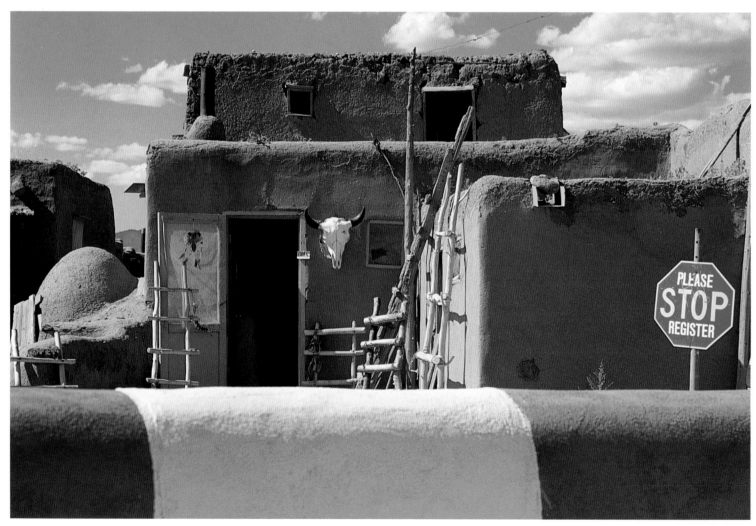

become a part of the pueblo construction and ladders are now used mainly to climb up for rooftop prayers at dawn and dusk.

Did other New Mexican pueblos have a similar architectural design when Coronado arrived in 1540? Historic documents prove that they did. The reason that the other eighteen pueblos in the state—unlike Taos—no longer look the same today, however, is understandable. Because the Taos pueblo was the most remote of all the New Mexican pueblos and therefore had the least contact with foreign elements, it avoided change. Also, the inhabitants of the Taos pueblo traditionally have been the most conservative of all New Mexico's pueblo inhabitants. The two thousand–plus Indians who belong to the pueblo (roughly one hundred of whom live in the pueblo all year—without plumbing or electricity) have always sought to maintain the pueblo's traditional way of life—its customs, its language, and its architecture.

Fortunately, the ruling powers that were and are in New Mexico have permitted the pueblos' ways of life to continue remarkably intact. The preservation began when Spanish kings gave each pueblo the land that extended a league outward in each direction from the pueblo church. Later, the Mexican government continued the land grant.

Finally in the 1848 Treaty of Guadalupe Hidalgo with Mexico, the U.S. government went along with the agreement, stating the pueblos would be "maintained and protected in the free enjoyment of their liberty and property."

On the edge of present-day Taos, nestled in a valley at the foot of the mountains, the pueblo had a strong effect on D.H. Lawrence when he was living outside town on the Kiowa Ranch, given to him by Mabel Dodge Luhan in exchange for the manuscript of *Sons and Lovers*. A fan of Indian dances, Lawrence wrote that the pueblo was "rather like one of the old

A handpainted, wooden feather dangles over the door to one of the pueblo's still-lived-in houses.

monasteries, when you get there you feel something final. There is an arrival." A self-governing community, a little like a Greek city-state, the pueblo elects its officials yearly. The governor is the most important and carries two canes of office, one given to the pueblo by King Charles V of Spain, the other given by President Abraham Lincoln.

The War Chief is responsible for "foreign relations," a task that has always been of considerable difficulty when dealing with the white man. The list of disagreements is endless. It includes a particularly unsavory period in the 1920s when the Anglo-controlled Bureau of Indian Affairs in Washington accused pueblo residents of being "half animals" and "pagan worshippers." The Bureau then attempted to outlaw pueblo dances and ceremonies unless

held at times and under circumstances approved by the Bureau. Fortunately, the Bureau was unsuccessful.

The Pueblo Indians already knew what it was to be harassed. In an 1846–47 uprising to get rid of Governor Bent and the American government, the pueblo inhabitants sought refuge in their church. U.S. forces bombarded the church, killing everyone inside.

Later on, in 1906, the government struck again and took away 46,000 acres of the pueblo's adjacent land, including sacred Blue Lake, a centuries-old religious site. For the next 64 years, the pueblo fought Washington. In 1924, it refused a $300 million offer from the federal Public Lands Commission in exchange for the pueblo's willingness to give up its claim. Increasing their lobbying in the 1960s, the

pueblo elders got then-Secretary of the Interior Stewart Udall, Adlai Stevenson, and Robert Kennedy to speak on their behalf. The National Council of Churches was also on their side.

In 1970, President Nixon signed H.R. 471 and the Taos pueblo got back its land despite the longtime battle waged against it by public recreation, timber, and development interests.

Charging for admission, also a camera and painting fee to outsiders, the pueblo today continues to be one of America's most remarkably preserved, historic sites. With a good deal of the pueblo off-limits, including the sacred kivas where the elders convene, visitors observe a way of life remarkably uncontaminated by outside influences or conveniences, including electricity and plumbing. While rarely wearing

The exterior of the present-day San Geronimo Mission needs regular repainting because of frequent rains and hard winters. Ladders lead to the pueblo's second story.

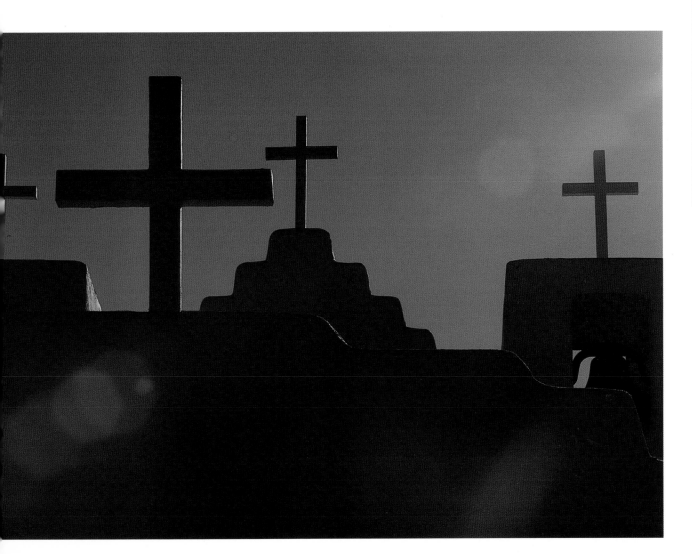

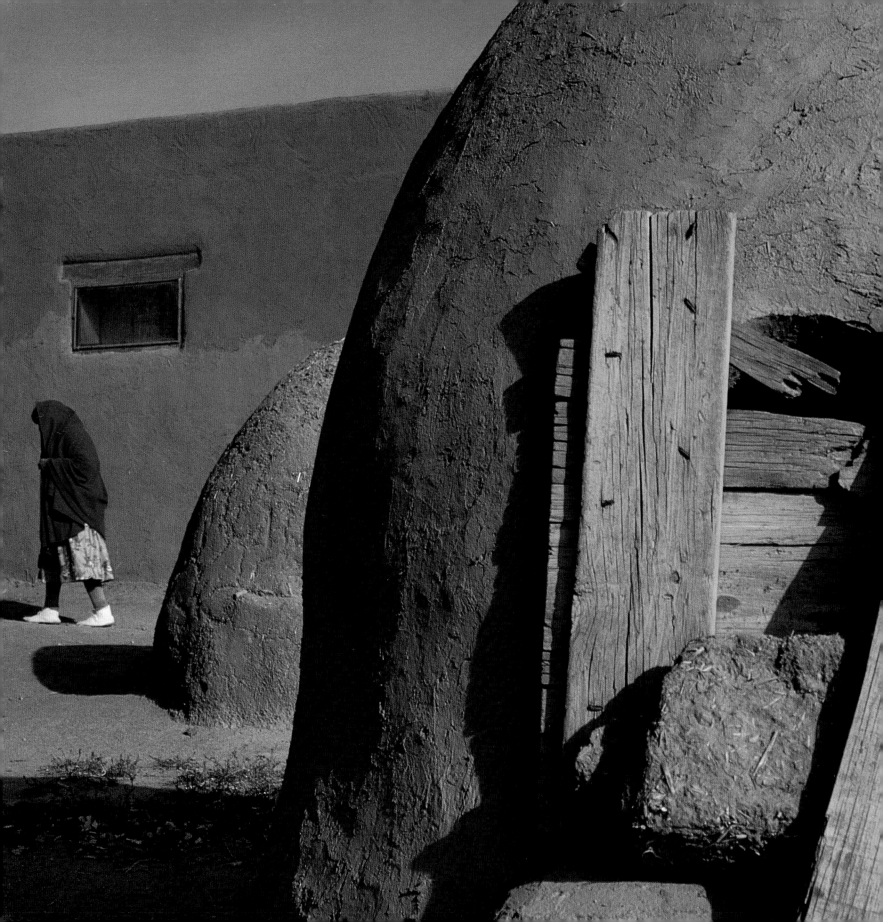

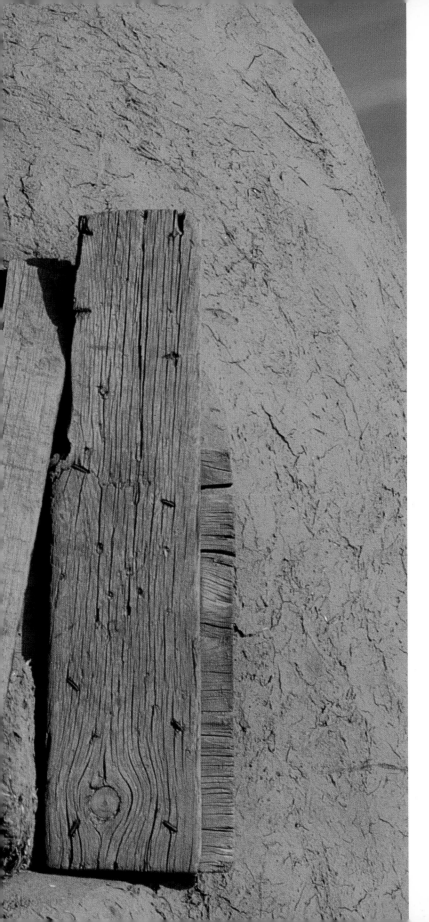

a blanket over their heads and shoulders, a custom common in Mabel Dodge Luhan's era and depicted by many early painters, pueblo residents do observe the pueblo's feast and ceremonial days with traditional solemnity and a great deal of dancing. No photography allowed!

The September 30th feast of San Geronimo, the pueblo's patron saint, is one of the most colorful. At this event, and throughout the year, loaves of bread are baked daily in *hornos*, adobe beehive ovens thought to have been introduced to the pueblos by the Spanish, who had themselves learned about the ovens from the Moors.

Will the Taos pueblo ever be made off-limits to outsiders? It has been suggested, but the chances of it happening are slim. "We don't want to close the door," a young Native American explained. "But we do need to hang a sign on it, a sign that says, 'Taos Pueblo: Fragile. Handle with Care.'"

Introduced by the Spanish, *hornos* (ovens) are used for baking, especially bread.

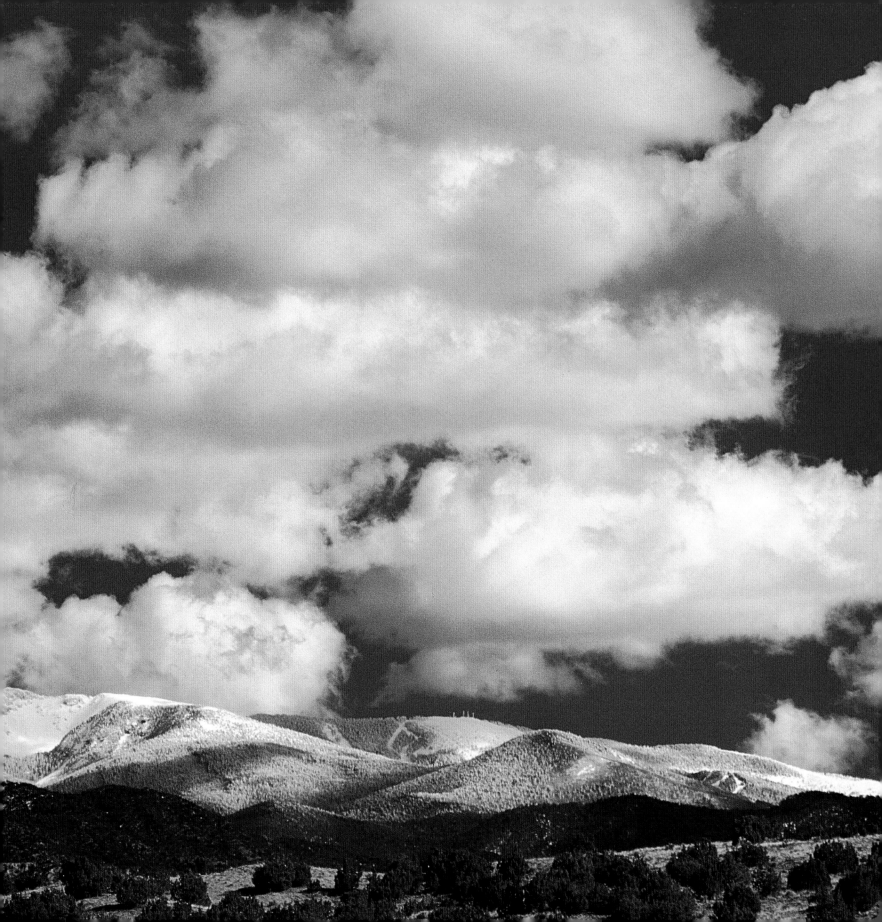

COYOTE COUNTRY

You take the low road and I'll take the high road and you'll be in Taos before me. True, but time isn't everything. Take the low road—or main road—that hugs the Rio Grande valley, and you'll miss some of the prettiest mountain scenery and most unspoiled old Hispanic towns in northern New Mexico. It isn't that the main road north from Santa Fe isn't scenic. It is. In fact, if you didn't know the old road north was there and if you didn't experience for yourself its historic, eye-dazzling pleasures, four-lane Highway 84 would do just fine. ✳ Now that you know about the High Road, take it, turn right at Pojoaque. Like so many Hispanic communities, Pojoaque was settled because it has water. Many Santa Feans prefer to live there and drive twenty minutes into town. They like the tall cottonwood trees that give shade to their restored flat-roofed pueblo-style and pitched-roof northern-New-Mexico-style houses with their wrap-around portals. ✳ Farther along the road, the Nambe pueblo, with

left: The High Road between Santa Fe and Taos hugs the slopes of the Sangre de Cristo mountains as it passes through ancient Hispanic villages.

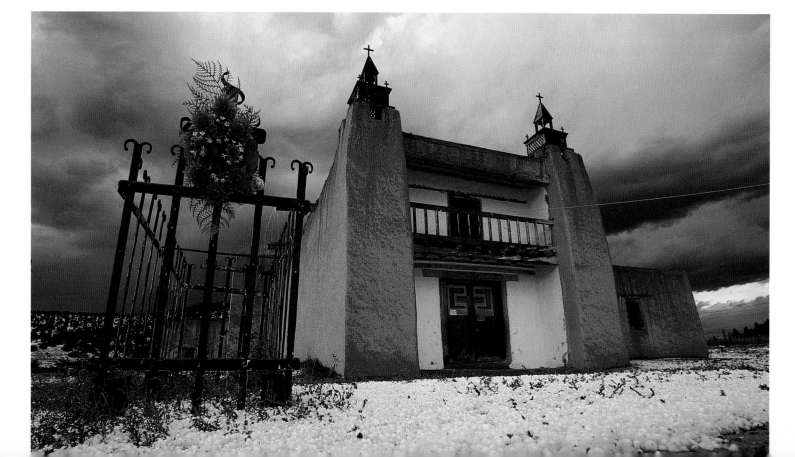

its eighteenth-century adobe church, is testimony to the fact that Indians learned to share rivers and streams with their Hispanic brothers, some of whom laid their houses' foundations in nearby Cundijo. "I'm working now, before the sun is high," explains eighty-two-year-old Manuel Vijil in his soft Spanish accent. Gentle, friendly, amused by the number of "gringos" passing by his house in their rental cars, Vijil delights in sharing local lore with strangers. "Dry summer, dry winter. Better stock up on apples," he says. "Go on down to the orchard. Pick as many as you want." It's 8:30 A.M. and already he's restrung over thirty yards of barbed wire fences to keep his horses in the paddock.

Passing through badlands with sun-baked mesas and buttes bleached white by the noonday sun and bathed in ochre and dusty rose sunlight at dawn and dusk, early travelers cut trees for *vigas* (roof beams) and *latillas* (cross-hatching) in another tucked-away valley further into

the Sangre de Cristo. Chimayo, with its Santuario, a kind of American Lourdes, draws up to thirty thousand pilgrims during Holy Week. Built by the Abeyta family in the late 1800s and privately owned until the 1920s, the sanctuary at Easter draws old men and women, cross-carrying young men, hymn-singing wives and children. Many of the pilgrims, having come to Chimayo from throughout New Mexico, park their cars to walk the final miles.

Dedicated to our Lord of Esquipulas—a village in Guatamala whose church is noted for its *tierra bendita* (holy earth)—the church in Chimayo stands on land where a sixteenth-century healing spring drew Indians. When it dried up, they settled for mud.

Today, to the left of an enormous *reredos* (brightly painted altar screen), there is a small room in the Chimayo church. Crowded inside, believers bend down over a hole to scoop up some soil. A nearby signs reads, "Please! Only small amounts of

After a glorious winter sunset, a snowstorm often buries villages in the eighteenth-century town of Las Trampas. Parishioners at the church of San Jose de Gracie seek warmth inside.

Holy Dirt per family." The holy-dirt room is remarkable for its symbols of healings and offerings of hope. There are abandoned crutches and canes and *ex voto* renditions of crippled legs, withered arms, and disfunctioning organs. Fistfuls of rosaries and scores of heart-rending thank-you notes add to the clutter. Flickering candles throw shadows on doleful, plaster-of-Paris madonnas. And the stifling hot air is pungent with the smell of dripping candlewax.

At the other end of town, the Ortega and Trujillo families—Chimayo weavers for generations—draw devotees to their looms as well. Tracing their roots back to when sheep were one of colonial New Mexico's greatest economic resources—their meat and wool were money in the bank—the families continue to include Rio Grande blankets in their weaving

repertoires. Historians trace the stripes of the blankets back to the Moroccan-Berber influence on the Spanish.

Another local industry is the more than thirty body shops that draw customers from throughout the area who want vintage cars turned into lowriders. Costing their owners anywhere from $5,000 to $20,000 to convert into automobiles that almost touch the road and that can be made to jump up and down like a cat on a hot tin roof, the lowrider has become a major part of any young Hispanic male's dowry.

Leaving Chimayo, automobile drivers see a sign for nearby Cordova, another off-the-beaten-path village. Noted for the purity of its residents' spoken Spanish, almost pure Castillian, the settlement draws outsiders interested in purchasing traditional wood carvings *(santos)* whittled

from white aspen and fragrant red cedar by present-day makers of religious images *(santeros)*. Antique carvings command the highest price, of course—look out for fakes!—but contemporary carvers are doing quite well and often have orders for years ahead.

Past Cordova, the already cool air becomes cooler as the High Road climbs steadily into the Highlands, where lush meadows are reminiscent of Bavaria and the air is pungent with the blended aroma of wild sage and acrid chamisa. Here, 13,000-foot-high peaks loom over the mountain towns of Truchas— the trout—and Trampas—the trap. Founded by the Spanish in the eighteenth century as military, agrarian outposts to protect Santa Fe from attacks by Plains Indians, both towns retain their unsophis-

Hispanic youths—
especially in the
towns of Española
and Chimayo—
turn vintage auto-
mobiles into low
riders, often with
remarkable artistry.
Memorials in local
cemeteries can be
considered works
of art as well.

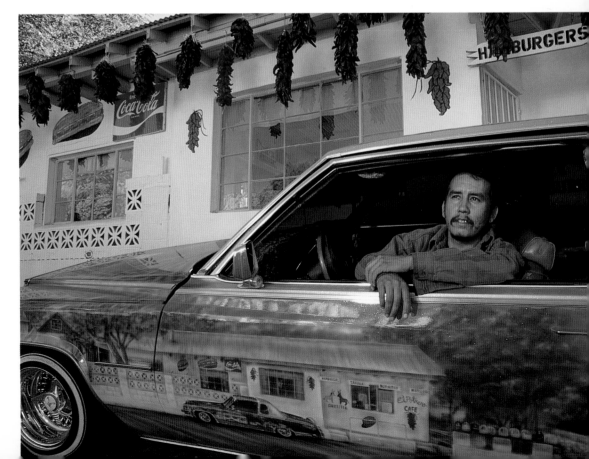

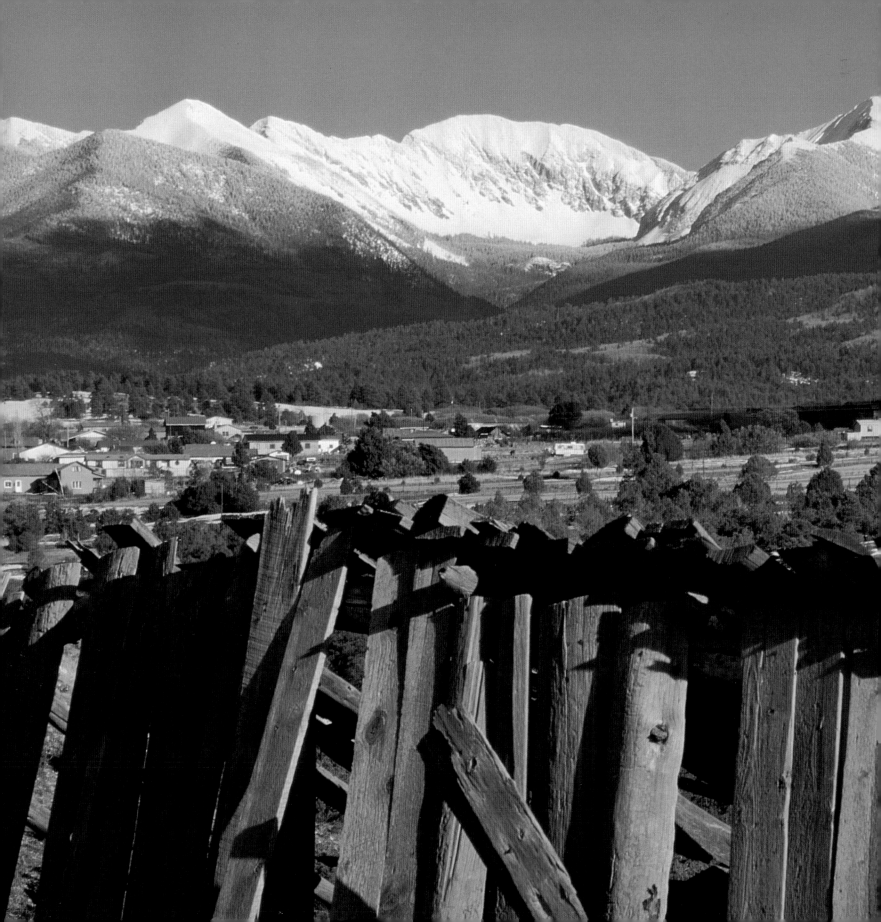

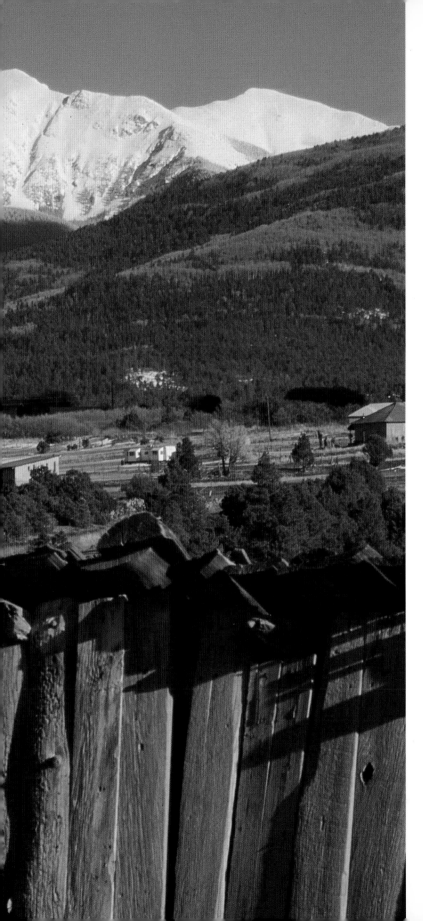

ticated, hardworking, out-of-the-way looks.

Centuries ago, settlers built each village around a plaza, the entrance to which was a narrow gateway between houses and wide enough only for a *carreta* (cart) to squeeze through. Villagers wanted to keep outsiders out. Even today, few Anglos take up residence along the High Road.

With fewer than fifty families in each town who struggle to farm what remains of their centuries-old land grants, the populations of Truchas and Trampas, as elsewhere in northern New Mexico, band together under a *mayordomo* (head man) to keep their communal *acequias* (irrigation ditches) clean and flowing. The system is another Moorish tradition introduced to the Spanish, who brought it to the New World.

It is reason enough to drive the High Road to see the church of San Jose de

Incredibly blue skies, temperatures in the 50s, and snow-covered mountains make the town of Truchas—and all northern New Mexico—a true winter paradise.

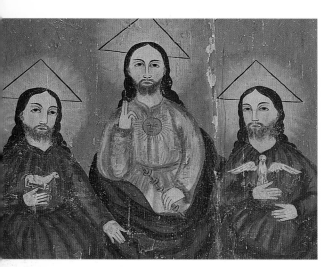

Eighteenth-century churches on the High Road contain remarkable religious paintings and altar screens. Santuario de Chimayo, a church built in the late nineteenth century, is famous for its *tierra bendita,* holy earth, used for healing.

Gracie at Las Trampas—the village where Robert Redford filmed *The Milagro Beanfield War.* In 1752, twelve families sought and gained permission from the governor of Santa Fe to build their own church. Comanche raids made it too dangerous for them to go to the church at the nearby Picuris pueblo. Tithing a sixth of their incomes for the church's construction, settlers erected wooden bell towers on both ends of the facade and a second-floor balcony, then turned to their women to put on the final coat of adobe.

The adobe finishing coat is by tradition an all-female finishing touch whose practice lingers throughout northern New Mexico to this day. In the late 1980s, when the church was badly in need of restoration, it was in fact a woman, Anita Rodriguez, a noted *enjarradora* (plasterer, embellisher, and remodeler of adobe), who took on the job. No other building material, she says, is as wonderful to work with as adobe. Water mixed with earth,

straw, sand, and pebbles, then molded and dried in the sun, adobe—or mud—bricks, weighing thirty pounds apiece, "are an incredible plastic material," Rodriguez says. "The idea that a building must be plumb, square, smooth, and sharp-edged is an industrial notion. We can take an axe and put in a window. The [adobe] architectural style is cultural, the technology is oral, and the materials are local."

Another technique that Rodriguez resurrected and which is seen in the church is *alisando.* To produce a soft luminosity, a thin layer of pink, gold, or tan adobe is mixed with mica.

The church at Trampas is Old New Mexico at its most spiritual, with ancient wooden pews, candlelit chandeliers lowered by rope from the ceiling, whitewashed walls towering up to centuries-old *vigas* and corbels, and an enormous altar screen dating back to when parishioners tied up their horses outside and stationed guards to keep on the lookout for Indians.

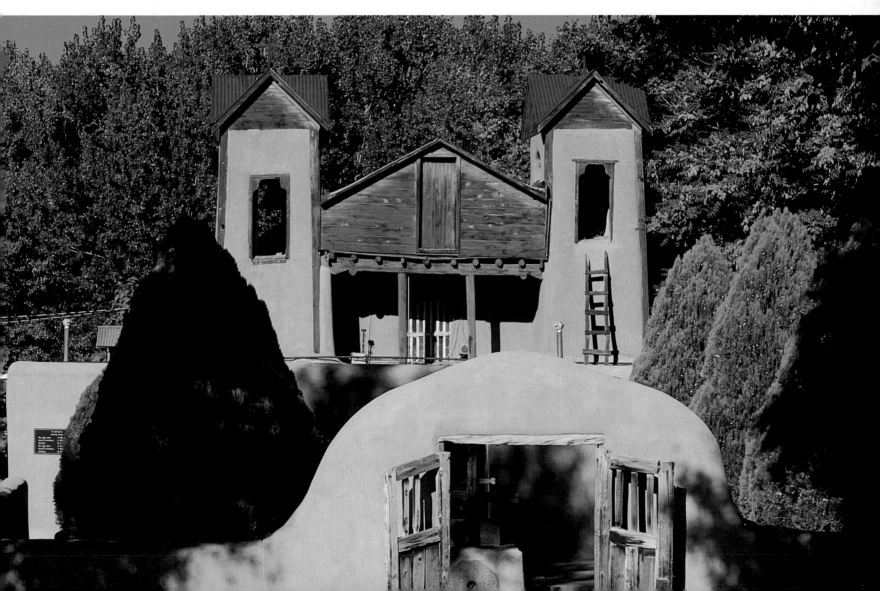

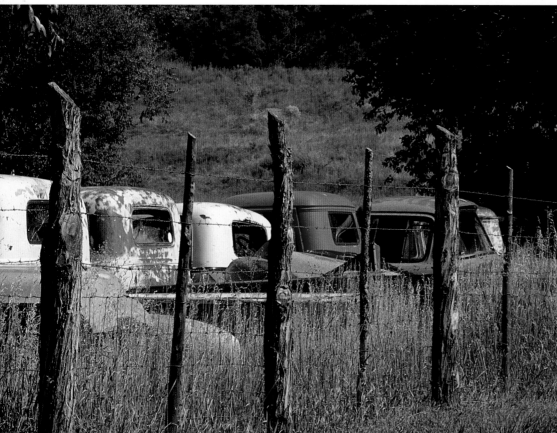

Today's culture is the most evident—unfortunately—along the High Road in the numerous abandoned cars, affordable but scenically disruptive trailer homes, and tilted telephone poles with their sway-backed wires. There are also a few general stores, numerous sagging porches, innumerable roadside crosses decorated with plastic flowers to mark fatal automobile accidents, and wood piles that can keep a family warm for years. "We put gunpowder in some of the logs. If someone is foolish enough to steal from you," an old-timer chuckles and says, "you can be sure he won't live to go to jail."

Traditions die hard in High Mountain towns, including Penasco and Chamisal, photographed by Russell Lee in 1940 for one of the legendary Farm Security Administration's Depression-era documentaries. If you look at the photographs hard enough, you can see examples of the area's purposely unpretentious *morradas*, a kind of unhallowed church built by

penitentes, an all-male Hispanic "order." Groups of *penitentes* sprang up in the nineteenth century as a type of lay clergy when the church couldn't send enough priests to cater to the religious, economic, and social needs of northern New Mexico. Still active, some say increasing in number, *penitentes* have long been rumored to flagellate themselves raw and to stage mock crucifixions. Who knows? Certainly no outsider. The brotherhood keeps to itself.

Coming down off the High Road, passing through forests of ponderosa pine, Engelmann spruce, and Douglas fir, and returning to the twentieth century and Taos, travelers sometimes doubt what they've seen. Was it real? Did they truly travel a stretch of road in the United States, most of which was only paved in the late 1960s, so totally free of motels, billboards, and restaurants?

There's only one way to find out. Turn around and go back.

Motorists on the High Road experience back-road New Mexico, passing rows of abandoned trucks and, in the fall, fields of yellow *chamisa* and purple asters.

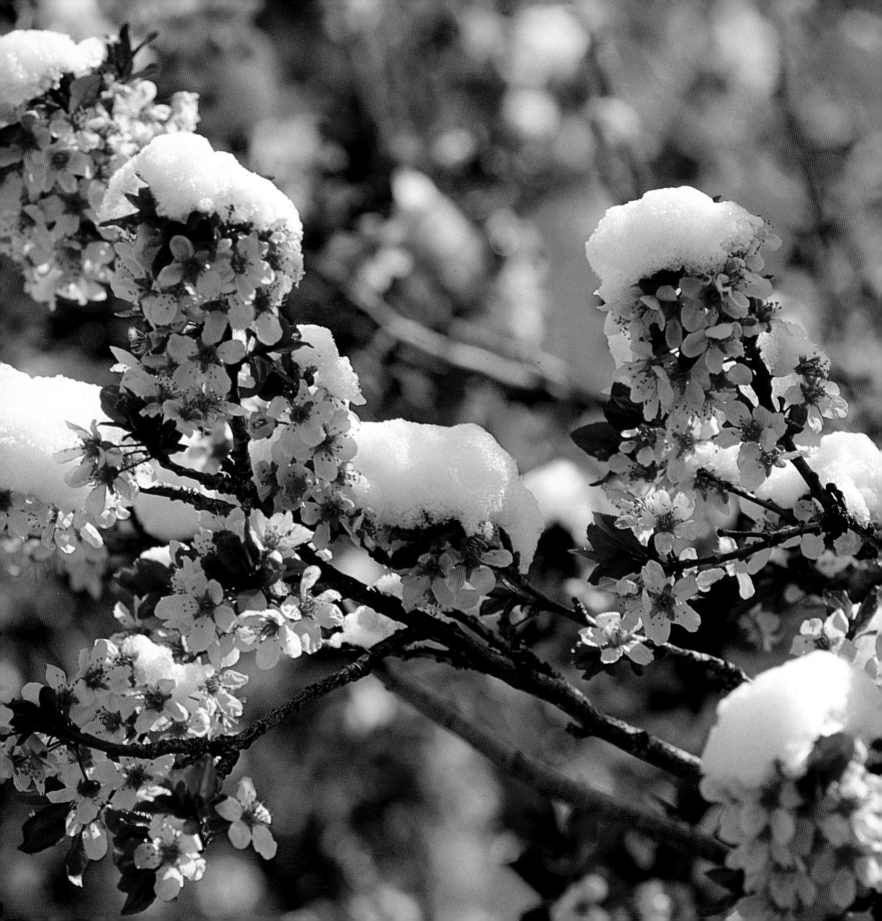

HIGH COUNTRY SEASONS

There's a major misconception about northern New Mexico. Tell someone in Nebraska that you're going to Santa Fe or Taos in winter and—chances are—he'll tell you that you're lucky to go where it's warm. Wrong. It snows in northern New Mexico, beginning some years in mid-October. Ski lifts open on Thanksgiving Day. Tell someone in Vermont that you're going to northern New Mexico in the summer and—you can bet—he'll pity you, thinking that it will be scorching hot. Wrong again. Northern New Mexico is seven thousand feet above sea level. When Texans and Oklahomans are laid out flat with July and August heat, people in Santa Fe and Taos are experiencing balmy summer days in the 80s—with low humidity—and cool evenings. Sweaters—even fires—aren't unusual in northern New Mexico when the rest of the nation is baking. ❀ Northern New Mexico isn't bone-dry desert as so many people mistakenly think. Oh, there are some cacti. But they're low-

left: Winter and spring in Santa Fe and Taos often overlap. Here, fruit trees are harmed by a late frost.

lying, puny things with small yellow and red flowers—nothing big and dramatic like the giant cacti in Arizona. Sure, there are big balls of prickly tumbleweed that get caught in barbed wire fences after they've hopscotched along the highways—but desert like you find around Tucson and Palm Springs? No way. The piñon-covered landscapes and colorful vegetation around Santa Fe and Taos tell the story of High Country, a very different topography from what people might expect.

Oliver La Farge, the Pulitzer Prize–winning New Mexican author, captured in words the state's northern landscape with powerful simplicity. "Mountain country, like the seacoast, is enemy to incredulity. The very name . . . Sangre de Cristo [mountains] has the ring of wonders," he wrote in *Behind the Mountains*, tales of the Baca family and ranch life near Rociada. "The first Spaniards felt their hearts uplifted when, after months of antlike marching across the baking southern

deserts, they came upon these snow-capped peaks. And when, at sunset, they saw the shining whiteness all across the eastern horizon turn to a glow of carmine tinged with purple, the sense of awe and beauty filled them. With faith and poetry, they gave the range its name, Mountains of the Blood of Christ—surely one of the strongest in all geography."

The Sangre de Cristos are indeed snow-covered in winter, but along with the neighboring Jemez and Sandias—they are also bottle green in summer and golden in the fall. Their forests are full of aspens, willows, and ponderosa pines; their fields are covered with wild iris and purple asters. Northern New Mexican country roads are lined with yellow chamisa and wild sunflowers; expanses are unexpectedly cut through with deep, sandy arroyos. Rich, irrigated farmland is cultivated with chile fields and dappled with fruit orchards. A giant river—the Rio Grande; a medium-sized river—the Chama; a small river—the Pecos: they

With four distinct seasons, northern New Mexico has spring flowers, fall foliage, and lots of chile peppers and pumpkins, too.

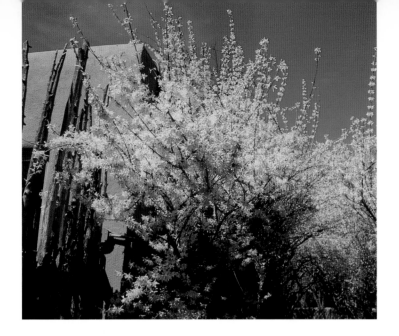

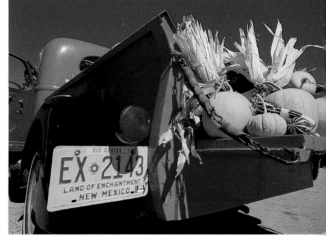

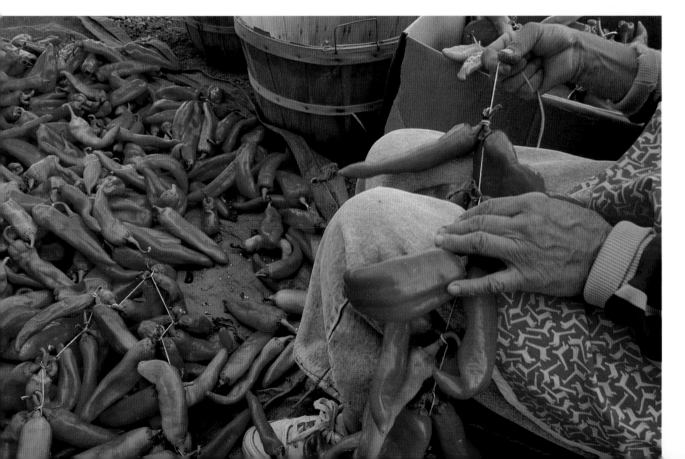

are all here today. Yesterday they weren't— geologically speaking, that is.

Most of New Mexico took shape over 600 million years ago. The landscape surrounding Santa Fe and Taos felt its final upheaval more recently, a mere 400 million years ago. In its formative years, the area was a bubbling cauldron of ever changing geological activity. Every couple hundred million years or so, the landscape would be different. Northern New Mexico went through a lot: endless volcanic eruptions oozing red-hot lava and tossing boulders and rocks as far as Kansas; mammoth oceans full of marine life with endless tropical shorelines and wide, sandy beaches; emerging mountains breaking through the earth's surface, only to rise higher and higher.

Geologists aren't the only modern-day detectives interested in the area's past. Fossil hounds are equally enthralled by New Mexico's rich deposits of bones belonging to dinosaurs, mastodons, camels, and rhinos that roamed the prehistoric landscape in search of food. Today, where scruffy tundra stretches out to distant plateaus, mesas and buttes, rain forests—with trees towering over 150 feet—and thundering rivers once existed.

Indian pottery shards in lava fields indicate that northern New Mexico was still kicking up its heels as recently as a thousand years ago. The turbulence that once shook the earth underneath modern-day Santa Fe and Taos is over, but the fabulous contortions and upheavals that the earth experienced left a landscape as varied and majestic as anywhere on planet Earth. Layers of multi-colored mineral deposits give deep gorges and towering escarpments a vivid story line. Buried under snow in winter, longing for a thunderstorm in summer, juniper-dotted plains lie between piñon-clad hills. The breadth, majesty, and soul-filled landscape of northern New Mexico has long enthralled painters and writers. There is certainly no shortage of inspiration: constantly changing cloud formations; the cacophonous excitement of a wraparound summer thunderstorm; multiple rainbows arching from mountaintop to riverbed; the approach of a snow storm; pumpkins and chile ristras in the fall; lilacs and bluebirds in the spring.

The seasons, the landscapes, the views, the vistas, the joy, the awe, the marvel of being able to appreciate northern New Mexico—no wonder the Indians are grateful to Mother Earth and Father Sky.

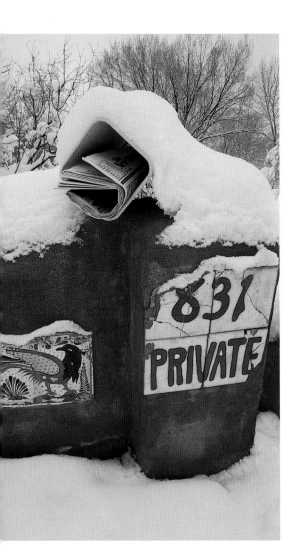

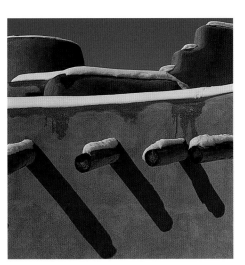

Residents of Santa Fe and Taos infrequently have to shovel snow. It is usually melted away by 10 A.M.

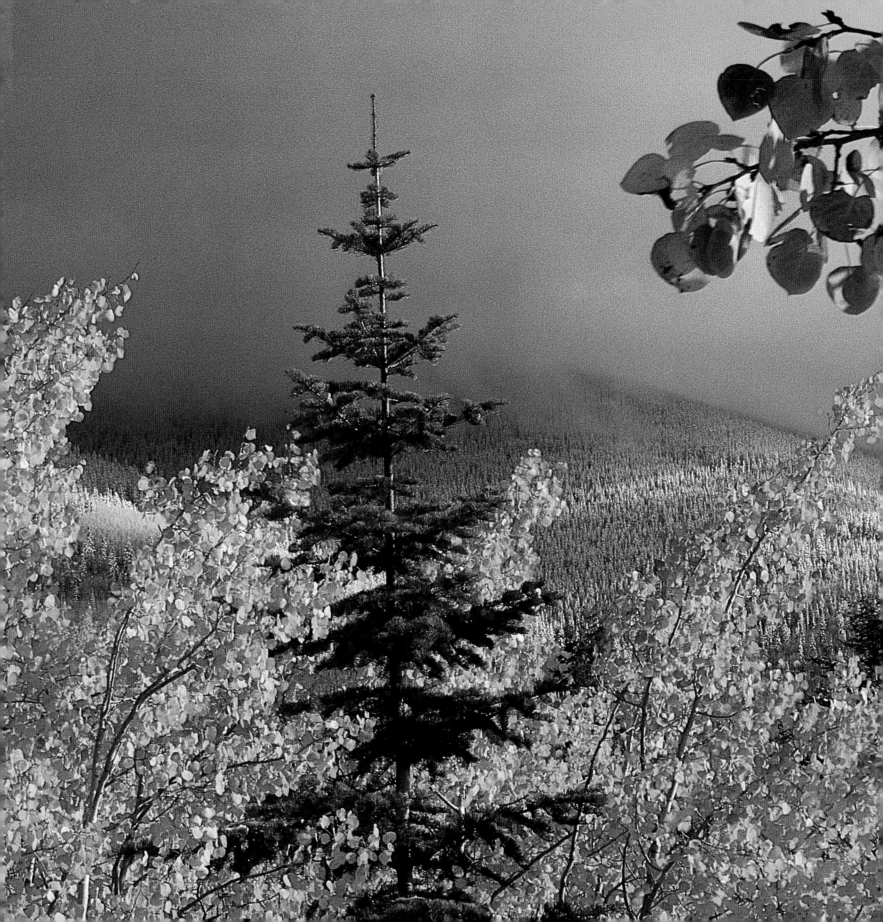

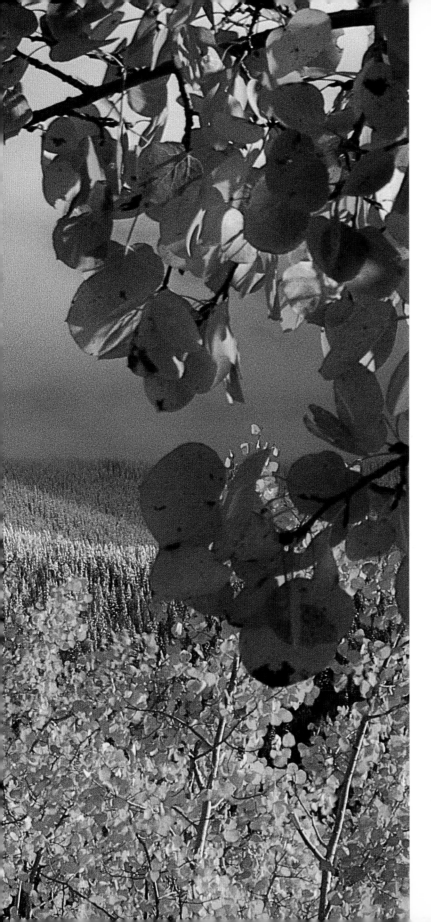

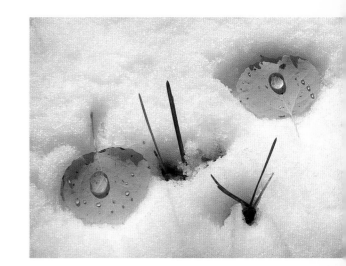

Throughout the
Sangre de Cristo
Mountains, aspen
trees turn to gold in
autumn. An early
snowstorm adds
even greater beauty.

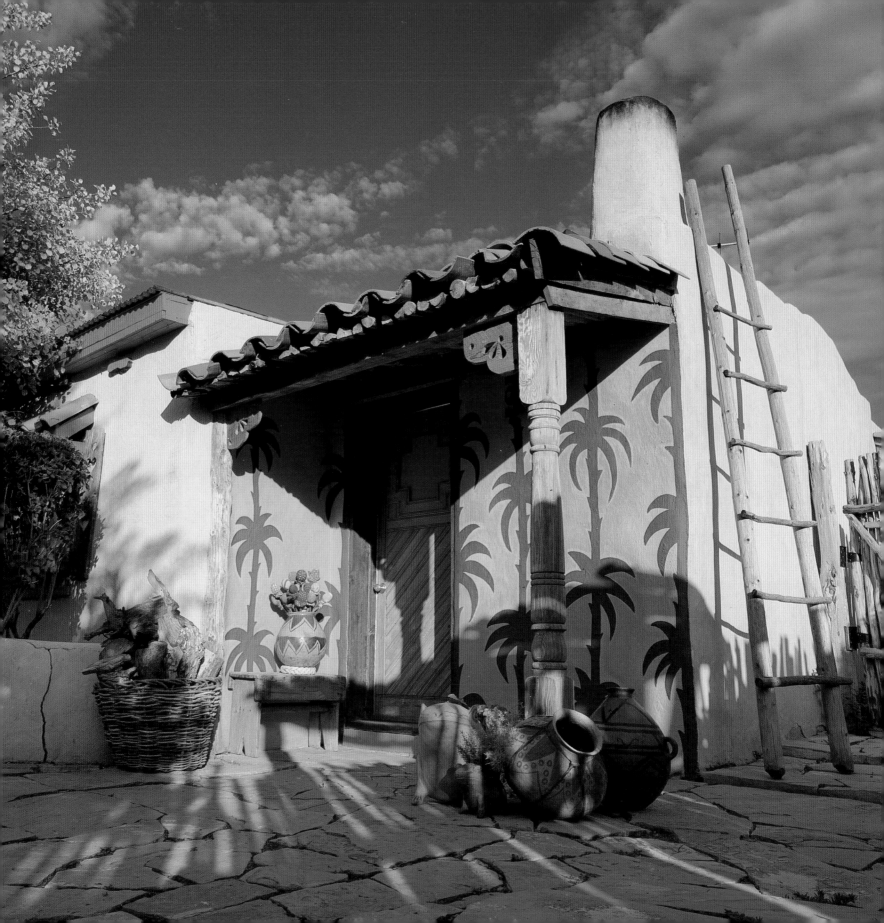

SANTA FE AND TAOS: A SENSE OF PLACE

What clapboard is to New England and stone is to Bucks County, adobe is to New Mexico. The historic local building material was, in fact, used by Indians of the Southwest in prehistoric times. A mixture of earth, pebbles, sand, straw, and water, it was applied for centuries to the exterior of buildings on pueblos. A layer of adobe would be smeared and allowed to dry in the sun, then another layer would be spread out to dry. ✹ In the seventeenth century, the Spanish speeded things up. The Moors had introduced the art of adobe construction to Spain and the conquistadores carried their knowledge with them to the New World. Spanish missionaries demonstrated that by using wooden molds, hundreds of adobe bricks—each one weighing twenty-five to thirty pounds—could be made in a day. They also proved that the simpler the design of an adobe building, the faster it could go up. No vaulted ceilings. No stone work. Minimal fenestration. No wonder

left: Interior designer and artist **Nona Wesley** turned a nondescript **Taos** house into a vibrant Mexican *casita,* or small house. Palm trees don't grow in **New Mexico**!

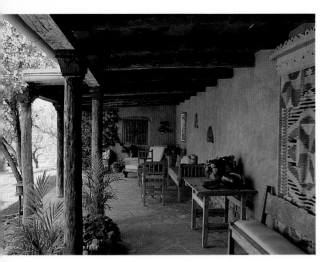

left: Introduced by the Spanish, *portals,* or porches, are common in **New** Mexico.

bottom: Adobe walls allow gardens to flourish in the sun while providing a good deal of privacy.

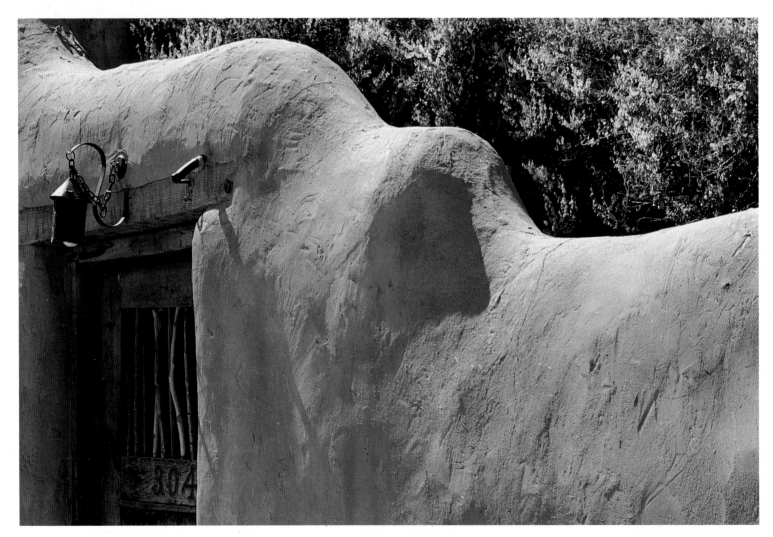

the early brothers were able to oversee the construction of over eighty adobe churches in northern New Mexico by the end of the nineteenth century.

Traveling north from Mexico City with a standard "building kit"—axes and spades, nails and hinges—missionaries introduced into northern New Mexico a way of constructing serenely simple, sublimely sophisticated buildings that are recognized to be some of America's greatest architectural treasures.

Even today in and around Santa Fe and Taos, almost all historic churches, private houses, public buildings, and pueblos remain adobe—at great expense and constant maintenance. At the same time, many contemporary buildings appear to be adobe, but they are not.

Looks—even with buildings—can be deceiving. Fortunately, the ever increasing number of housing developments, especially on the outskirts of Santa Fe, maintain a back-to-earth look. While architecturally neutral, and for the most part just plain ugly, they are at least rendered less conspicuous by their brown stucco exteriors.

The fact is, the cost of laying a single adobe brick bought from a commercial yard now costs from $2 to $3—far too much for many builders and clients to pay, especially if one lays them in double thickness. Today, "fauxdobe," or earth-toned stucco sometimes mixed with straw and swirled over frame, is the way most new homebuilders must go.

"It used to be that adobe bricks were inexpensive. They were an answered prayer for builders on a budget. Now they are a very upmarket way to put up a building," explains Tony Perry, a transplanted Englishman. His Santa Fe–based company, Straw Bale Builders, Inc., is a leader in what is fast becoming the way many homebuilders are headed, locally and nationally. Walls of straw are covered with "fauxdobe," producing an adobe look

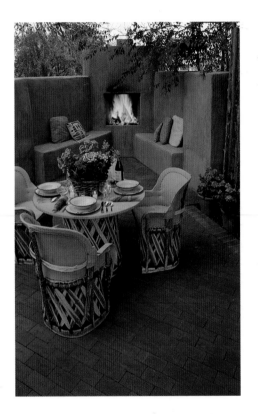

An outdoor adobe fireplace keeps dinner guests warm on a cool evening.

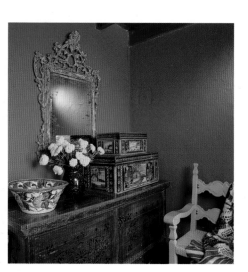

Furniture and accessories are beautifully displayed against oxblood adobe walls.

that can fool the experts. "Real adobe bricks are like gold bullion from Fort Knox," Perry says. "The marvel of Santa Fe and Taos is that people, albeit frequently in conformity with historic building codes, have maintained the adobe look, giving the two towns an integrity and architectural uniformity which is rare in the United States."

With the steady arrival of "outsiders" to Taos and Santa Fe beginning in the 1930s, a determination to live like the natives was included in their luggage. In addition to tuberculosis patients who came to Santa Fe's Sunmount Sanitarium and stayed after they were cured, the two towns attracted painters, writers, poets, playwrights, historians, archeologists, the rich and the famous, the strapped and the adventurous. They'd seen Paree, New York, Chicago, and Akron; now they wanted something different—and they wanted to get back to basics.

Today, people continue to fall in love with the down-to-earth lifestyle, as well as the earthy architectural integrity of Santa Fe's and Taos's adobe buildings with their wide porches (*portals*), rounded corner fireplaces (*kivas*), beamed ceilings (*vigas*), and tiled floors. An adobe building provides warmth, charm, and an organic, natural lived-in look that captures people's affection.

Painter Georgia O'Keeffe was one of the first of many twentieth-century newcomers to New Mexico to fall in love with and feel totally at home behind adobe walls. Tucked away in her Abiquiu hideaway, she insisted on uncluttered rooms and undecorated walls. Stark simplicity was a religion with her. She often said she needed space to think in. "Words aren't much good. You just have to feel it," she said about the spiritual serenity she achieved and others today seek when buying into the Santa Fe and Taos lifestyle.

For generations, residents of Santa Fe and Taos had little to choose from when it

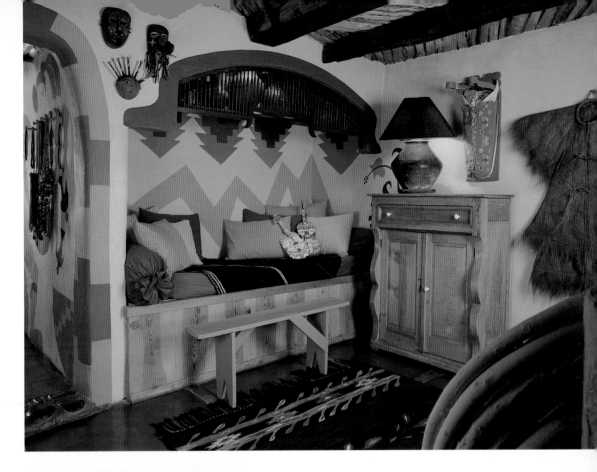

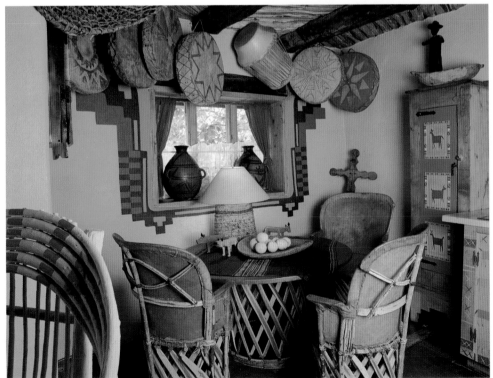

A frequent visitor to Mexico, Taos resident **Nona Wesley** has given her house a "south-of-the-border" look, which includes many items acquired from Tarahumara Indians. "I crave hot colors," Wesley says.

Colorful pots and
tiles in gardens and
courtyards around
Santa Fe and Taos
reveal the strong
influence of
Mexican culture.

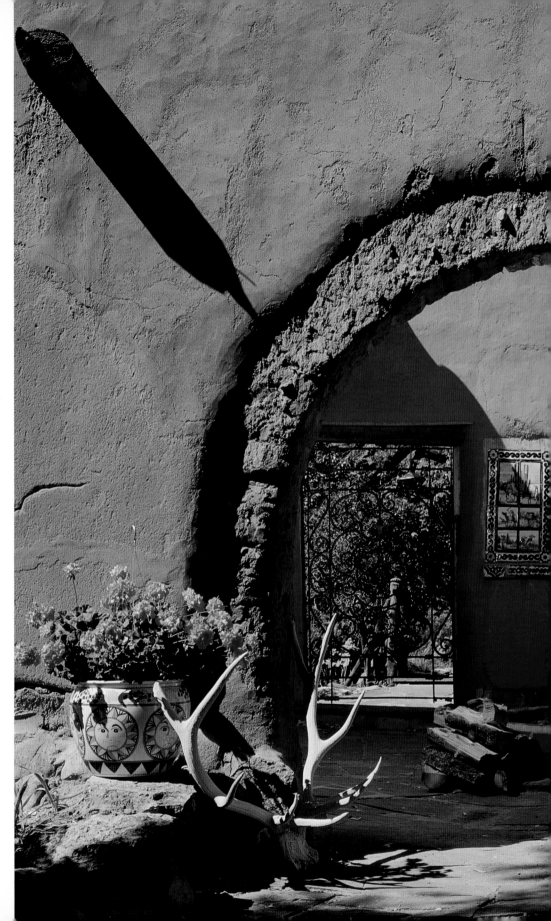

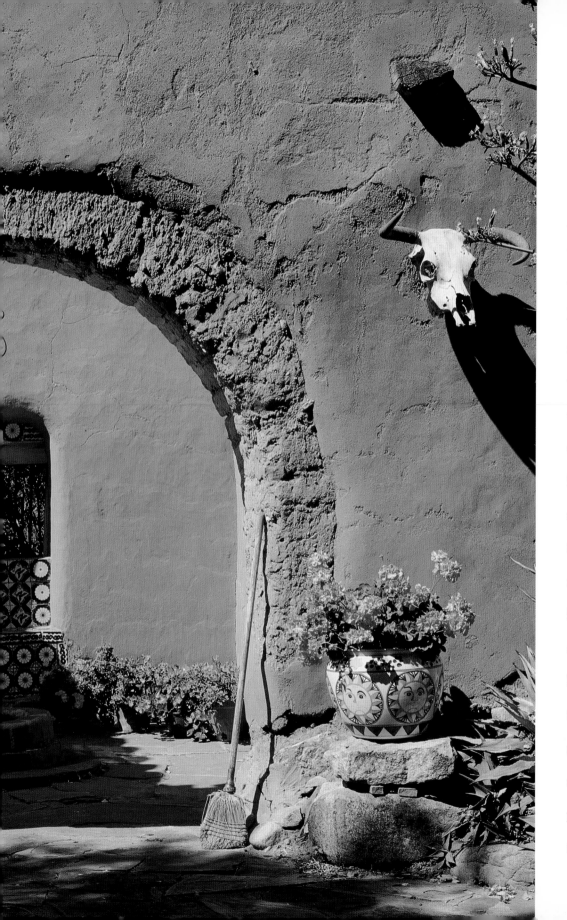

came to furnishings. At first they were over the border, then they were at the end of the trail. There were no Macy's, no Bloomingdale's, no catalogues to order from. If there were to be any personal touches in a house, they were seen in the extra touches that went into the house's construction and very utilitarian furnishings. Handmade furniture might have some decorative embellishments. Corbels (posts supporting the lintels of portals) might be carved in volute shapes and incised with fanciful designs. Beds, chairs, *trasteros* (chests), or an *alacena* (wooden cupboard built into the wall) might be distinctly carved. So might window frames, garden gates, and doors. A further effort at individuality could come from a coat of paint. Made from local clays and plants, the soft-hued eighteenth- and nineteenth-

century colors were warm, unstartling, and earthy.

The arrival of the railroad in the 1880s and the proliferation of general stores around the plazas of Santa Fe and Taos brought a wider selection of furnishings to homeowners. Pane glass for windows, tin sheeting for pitched roofs, and milled lumber for floorboards were now available. By then, the so-called Santa Fe style (it could just as reasonably be called Taos style) had taken hold. While locals weren't aware they had created a school of interior design, they had. It would simply take awhile for national, then international, recognition. Beginning in the late 1970s, American interior designers, department stores, and decorating magazines began to promote the fact that homeowners in Santa Fe and Taos did things differently.

Paris, Toyko, and London shops followed suit and offered customers a Southwest look in home furnishings.

Homeowners in the two towns hadn't purposely started "a look." Rather, by necessity, they had taken advantage of indigenous Native American and Hispanic crafts and folk art to decorate their houses. They had filled their *nichos* (wall niches) with *santos*, put candles in tin-work sconces and chandeliers, and covered tables and *bancos* with Rio Grande and Navajo weavings. Indian drums made excellent end and coffee tables.

Pueblo pots and collections of Hopi kachinas on open shelves and on top of chests gave a room a certain je ne sais quoi. Transplanted Easterners inevitably added some European and New England pieces to their houses in New Mexico. A

little Chippendale, a little Federal, a little Louis XIV, some Meisen, some Dresden, some Limoge; they weren't locked in to Oh So Santa Fe. They simply did what came naturally. Mix and match was the result of supply and demand.

Today, fortunately, "the look is much looser," says Susan Dupepe, a local interior designer whose clients have moved to New Mexico from the other forty-nine states, and Europe as well. "There is no question, people move to New Mexico because they want the New Mexican quality of life in a New Mexican house that reflects the New Mexican heritage. But there is a return to the more eclectic way of decorating that was so popular here in the 1930s and 1940s," she reports. "The innate good looks of New Mexican adobe architecture, architectural details, and

White walls lend a dramatic backdrop to houses frequently decorated with local handicrafts, old and new.

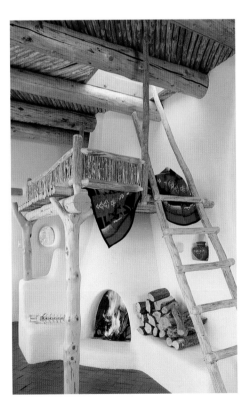

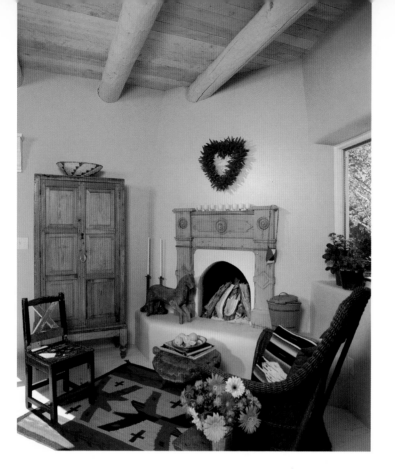

European and American antique furniture and decorations—plus hard-to-find New Mexican pieces—give these old adobe houses an imaginative, colorful, lived-in feeling.

antique furnishings lend themselves to being at home with the best of everything from everywhere: Morocco, China, Europe, the rest of America."

Where is the Santa Fe–Taos look headed? "Its national and its foreign popularity has died down, but it hasn't petered out. It was a phenomenon for awhile—but it won't go away," says a local store owner whose line of Southwestern furniture is sold globally. "It is too ingrained, too deeply rooted to go away."

Back in the 1920s, Carlos Vierra, one of the town's first artists whose pueblo-style house on the Old Santa Fe Trail combined the best of the past with the requirements of the day, explained the persistence of local style. "Progress in Santa Fe," he said, "is not so likely to come through imitation of methods and customs of any other town as through an appreciation and development of the great advantages we have had from the beginning."

Amen.

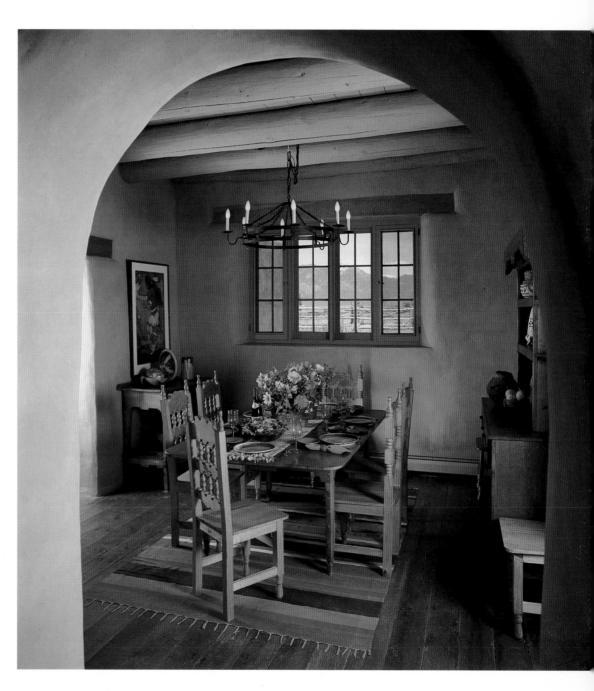

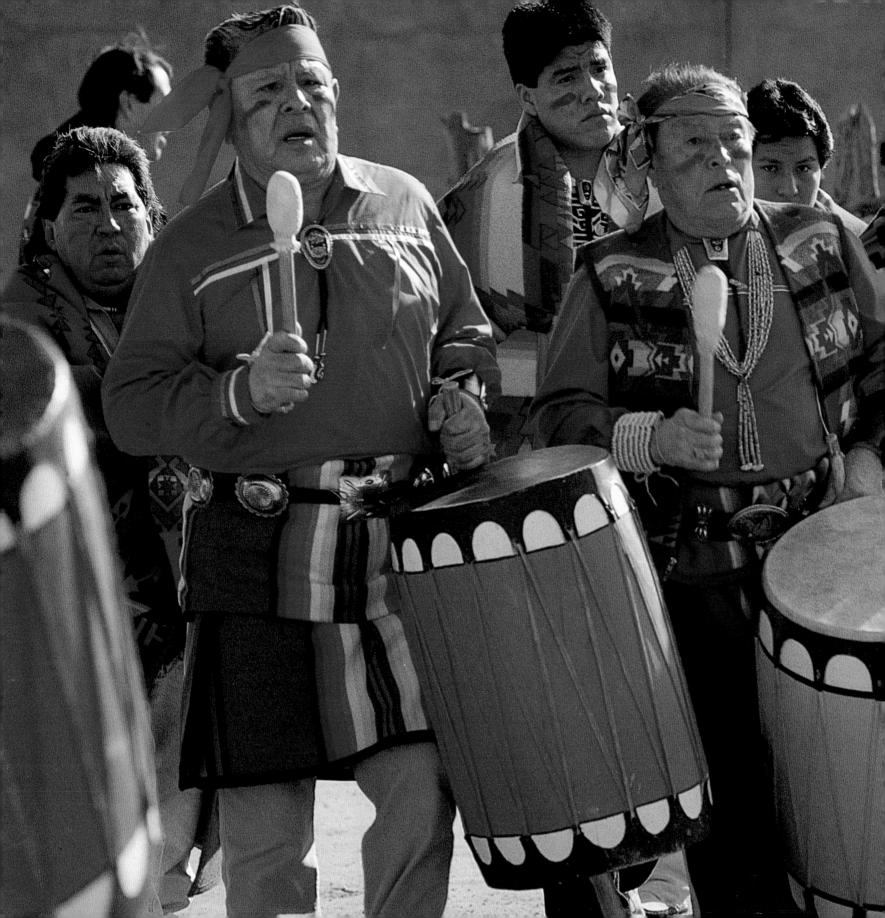

THE BEAT
OF THE DRUM

When someone in Santa Fe or Taos says he's going to the dances, he means one thing. He is going to dances held at one of the nearby Indian pueblos. Held throughout the year—on Christian holidays, on the feast day of the pueblo to honor its patron saint, in celebration of the seasons, to invoke blessings, to bring on the rain, to express gratitude to animals that keep one fed and clothed, to help raise corn, to cleanse the soul—dances have a wide variety of reasons for their performance. ❋ Intertribal powwows are not to be confused with pueblo dances. Dating back to victory dances when Plains Indian warrior societies mimicked the action of battles, powwows today are mainly "show dances," with dancers competing for prizes. ❋ For the outsider, the important point to realize is that for the most part, Indian dances at pueblos are religious. They are prayers. While others may fold their hands, kneel, and bow, Indians communicate with their feet, their drums, and their voices. No step,

left: Dances are performed throughout the year at the many Indian pueblos throughout northern New Mexico. Visitors are often welcome.

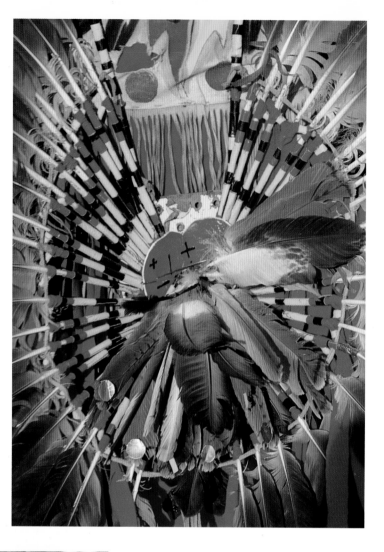

no body movement, no element of the costume, no beaten or sung note is performed at random. Each and every detail of a dance has a meaning, each has been passed down through the ages, and each has a message that is being transmitted out of the realm of the material into the world of the spiritual.

Indians firmly believe that the heartbeat is the center of the universe and that dance is the center of the heart. It is as natural for an Indian to dance as for a Muslim to chant or a Buddhist to spin a prayer wheel. "You cannot observe the heartbeat. You can only feel it. And to feel it, you must be a part of it," explains Taos pueblo dancer Benito Concha.

Frequently allowed to be observers, savvy visitors at pueblo dances understand the rules: speak softly, stay in marked-off

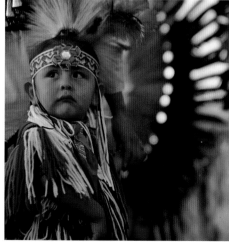

Indians from all over the United States compete for both costume and dance **prizes at the Taos powwow in July. Youngsters enjoy the fun, too.**

areas; do not point; do not applaud; and never, never take photographs unless they are permitted (they are occasionally, but always with a price tag).

To bring real meaning to a pueblo dance, to be aware that there are "more things in heaven and earth . . . than are dreamt of," visitors should arrive early to attend the usual service in the pueblo's church. Afterward, the dancers normally move across the plaza to a kiva, the most sacred meeting place on a pueblo, then file back onto the plazas for hours of very meaningful footwork.

Indian dancers have their own schedule. A dance may be scheduled for a certain day, but not for a precise time. A dance may even be called for at the last minute. To the outsider, it may appear that the performance is less than orga-

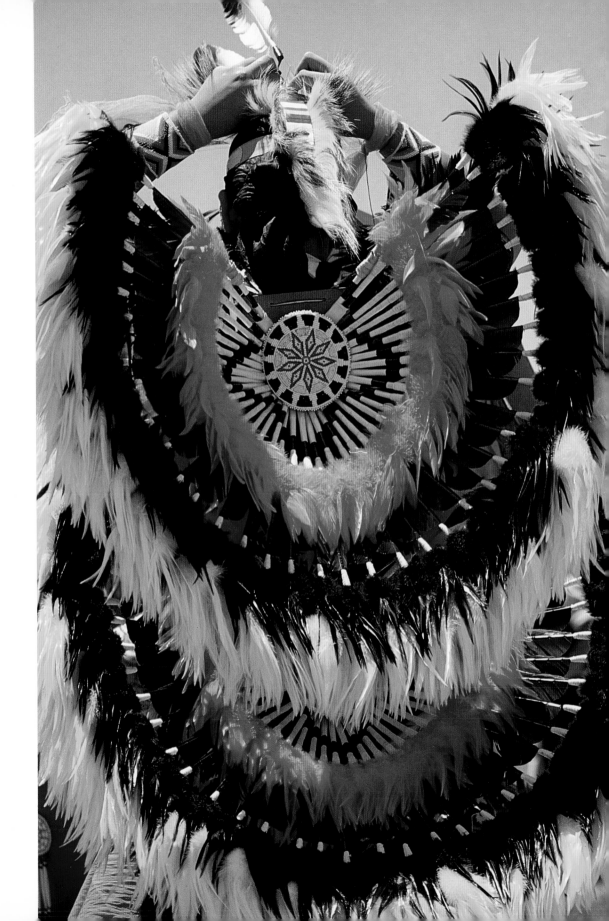

nized. Nothing could be further from the truth. Thoughtful preparations frequently go into a one-day, maybe even a three-day dance. Purified by fasting, sweat baths, visits to secret shrines, and the performance of secret rites, dancers are under the direction of the pueblo's medicine man, or *cacique*. Nothing is left to imagination. Everything is overseen with the greatest traditional demands. Participation is equally watched over by the elders. Every member of a pueblo must perform at least once a year in a ceremony, either as a dancer or as a member of the chorus. When not performing, they watch. Older men form the drum corps.

Divided into two "families," inhabitants of a pueblo are either the Summer People—also known as the Squash Clan, members of which paint themselves reddish brown—or the Winter People—also known as the Turquoise Clan, whose members paint themselves bluish.

With roots that go back more than a thousand years, dances performed in the pueblos of northern New Mexico are often dramatizations of religious myths and include the Corn Dance, the Eagle Dance, the Comanche Dance, the Buffalo Dance, the Deer Dance, the Parrot Dance, the Turtle Dance, and the Rainbow Dance. Each one has its own special meaning. Frequently, it is an invocation. Other times, it is a thank-you.

Los Matachines, which came to New Mexico from Spain, is the least Indian of all the dances. Depicting the triumph of Christianity over the indigenous faith of Montezuma and the Aztecs, the dance was taught to the Indians by Franciscan missionaries.

Wearing masks, jewelry, cornhusks, fox fur, fine white buckskins, evergreen ankle and wrist bracelets, headdresses (*tablitas*) for the women, dancers may number as many as five hundred people. Divided into teams, they alternate, they prance, they shuffle, they bend, they sway, they are in

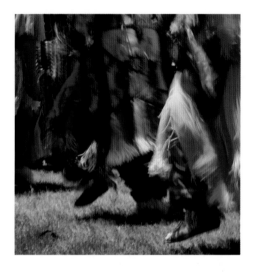

The fast-flying feathers, tasseled raiments, and beaded moccasins of the performers turn a powwow into an Impressionist tableau.

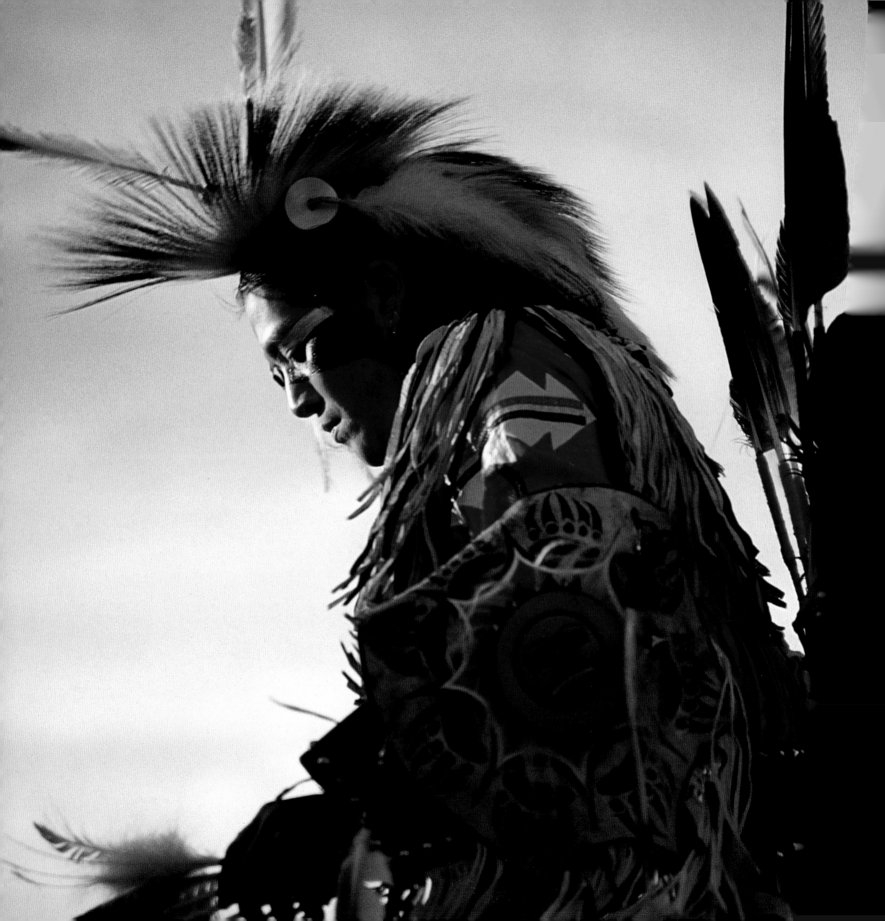

communion with one another and with nature. Exhibiting masterful control of body and breath, able to remain in unison despite tricky changes of tempo and rhythm, the long rows of dancers turn and change direction like falling dominoes. First one, then another, then another.

All the while, the drums beat. A chorus may join in. Lacking harmony, the audible effect is entirely through rhythms, often as many as four in one song. Short intervals. Long pauses. For the uninitiated, Indian music lacks melody. For devotees, it is the pulse, the biorhythm, the heartbeat of Mother Earth.

Humor is also part of the dances. As solemn and sacred as the principal dancers may be, clowns, or *koshare*, are quite the reverse. Believed to be invisible, to represent the spirit of the dead, they

are frequently covered with whitewash and have ominous, black-ringed eyes. Said to increase fertility in man and beast, the *koshares* can do whatever they wish. They joke obscenely, and single out people in the audience to be the brunt of their hit-and-run antics and lampooning. No one may complain, nor can their victims resent whatever embarrassing situation they find themselves in.

Dances frequently end with the same abruptness they started with. For the observer, what remains is profound wonder—wonder that he has been allowed to be there, wonder that something so ancient, so sacred is still going on. The women, their thick black hair tucked beneath brightly colored, striped shawls, pick up their Walmart folding chairs, walk past the hotdog and hamburger stands,

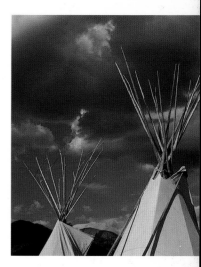

top: During the Taos powwow, tepees cover the plain near the pueblo.

left: Listening carefully to the drumbeat, a dance contestant measures his footsteps.

and disappear inside their adobe houses.

Lunch and dinner breaks at a dance are elaborate sitdown, family events to which Indians from other pueblos, as well as complete strangers, are often invited. Conversation is minimal. Silence pervades, only to be broken by a request to pass the bread, tamales, posole, fried chicken, mashed potatoes, gravy, cake, pie, or cookies. Large pitchers of Kool-Aid, iced tea and lemonade line the middle of the table.

With their phenomenal color, mesmeric repetition, obvious spiritual significance, and gut-level marriage of man to the land, Indian dances are often hard to explain. Painters have tried to pass the magic on with pigments and brush strokes.

Writers have done the same with words. Frank Waters in his book *Masked Gods* was remarkably successful when he wrote, "They began dancing, shaking their rattles at the cringing children . . . Dancing back and forth, back and forth

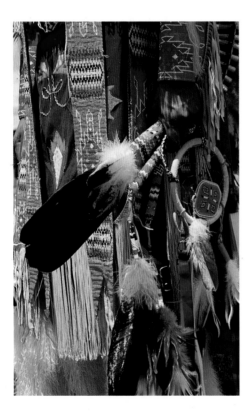

. . . No longer man nor beast nor bird, but embodied forces of earth and sky, swirling across the . . . blue mountains on the horizon, shaking this remote and rocky island, stirring awake the archaic wonders and mystery and pristine purity of man's appreciation of his cosmic role. Dancing as gods have always danced before their people. Masked by the grotesque, but commanding that comprehension of the heart which alone recognizes the beauty within."

Waters continued: "If there exists such a thing as a spirit of place, imbuing each of the continental masses of the world with its own unique and ineradicable sense of rhythm, mood and character, and if there exists an indigenous form of faith deriving from it, then it is to the Indian we must look for that expression of life's meaning . . . Whatever he is, whatever he believes, stems from the very soil of his ancient homeland. He is inseparable from the earth itself."

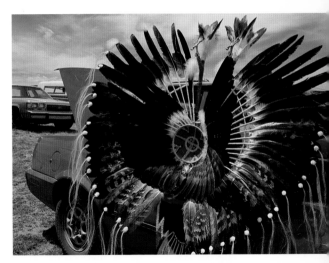

left: Waiting patiently for an invitation to join the dance, a performer stands at attention.

bottom: At Santa Clara pueblo, several hundred Indians dance together on Christmas day. Spectators must be quiet and never applaud.

right: Too heavy to wear when its owner is not performing, a feather bustle is hung on a car door.

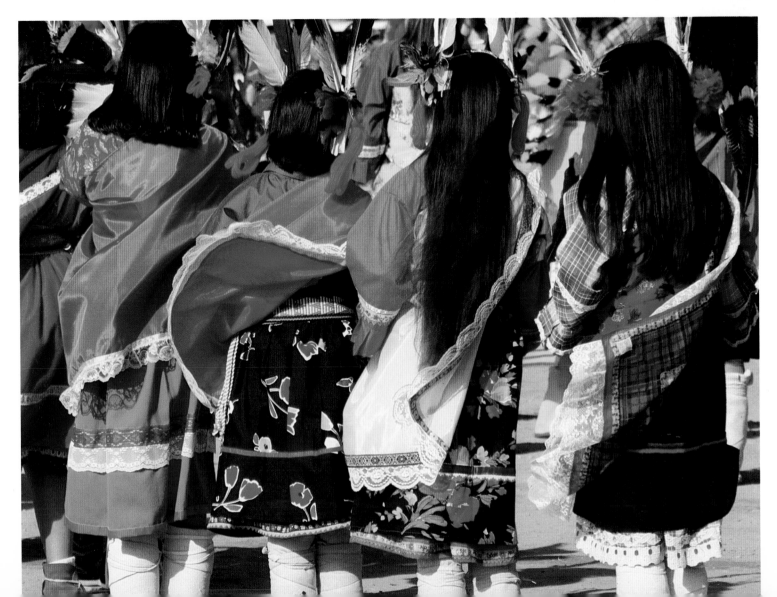

RESOURCE GUIDE

Information

Santa Fe Visitors Bureau
201 West Marcy St.
P.O. Box 909
Santa Fe, NM
87504-0909
800-777-2489

Taos Chamber of Commerce
P.O. Drawer 1
Taos, NM 87571
800-732-8267

Santa Fe Reservation Services

Accommodations Hotline
800-338-6877

Alternative Accommodations
800-995-2272

New Mexico Central Reservations
800-465-7829

Santa Fe Central Reservations
505-983-8200

There are an estimated 6,000 hotel rooms and more than 250 restaurants in Santa Fe and Taos. From July through October, also at Christmas, many are booked solidly. One doesn't just arrive and expect to find a free room or table. Therefore, advance reservations—whether to eat or sleep—are advisable. The following names are only a few of the many opportunities for eating and lodging. Most are either expensive or moderate. Few are bargains.

Santa Fe Hotels, Motels, Bed & Breakfasts

Alexander's Inn
529 East Palace Ave.
505-986-1431

Bishop's Lodge
Bishop's Lodge Rd.
800-288-7600

Budget Inn
725 Cerrillos Rd.
505-982-5952

Camas de Santa Fe
323 East Palace Ave.
505-984-1337

Castillo Inn
622 Castillo Place
505-982-1212

Dancing Ground of the Sun
711 Paseo de Peralta
505-986-9797

Days Inn
3650 Cerrillos Rd.
800-325-2525

Eldorado Hotel
309 West San Francisco St.
800-955-4455

El Rey Inn
1862 Cerrillos Rd.
505-982-1931

Fort Marcy Compound Condos
320 Artist Rd.
800-745-9910

Four Kachinas Inn
512 Webber St.
800-397-2564

Galisteo Inn
HC 75, Box 4
Galisteo
505-466-4000

Garrett's Desert Inn
311 Old Santa Fe Trail
800-888-2145

Grant Corner Inn
122 Grant Ave.
505-983-6678

High Mesa Inn
3347 Cerrillos Rd.
800-777-3347

Hilton of Santa Fe
100 Sandoval
800-445-8667

Homewood Suites
400 Griffin St.
800-225-5466

Hotel Santa Fe
Paseo de Peralta at Cerrillos Rd.
800-825-9876

Hotel St. Francis
211 Don Gaspar
800-666-5700

Howard Johnson Lodge
4044 Cerrillos Rd.
505-438-8950

Inn at Loretto
211 Old Santa Fe
Trail
800-528-1234

Inn of the Anasazi
113 Washington Ave.
800-688-8100

Inn of the Animal
Tracks
707 Paseo de Peralta
505-988-1546

Inn of the Governors
234 Don Gaspar
800-234-4532

Inn on the Alameda
303 East Alameda
800-289-2122

International Visitors
Hostel
1412 Cerrillos Rd.
505-988-1153

King's Rest Court
Motel
1452 Cerrillos Rd.
505-983-8879

La Fonda Hotel
100 East San
Francisco St.
800-523-5002

Lamplighter Motel
2405 Cerrillos Rd.
800-767-5267

La Posada Hotel
320 East Palace Ave.
800-727-5276

La Quinta Inn
4298 Cerrillos Rd.
800-531-5900

Las Palomas
119 Park Ave.
800-745-9910

La Tienda Inn
445 West San
Francisco St.
505-989-8259

Motel 6
3695 Cerrillos Rd.
505-473-1380
505-471-4140

Pecos Trail Inn
2239 Old Pecos
Trail
505-982-1943

The Radisson of
Santa Fe Hotel
750 North St.
Francis Drive
505-982-5591

Plaza Real
125 Washington
Ave.
800-279-4900

Preston House
106 Faithway
505-982-3465

Pueblo Bonito
138 West Manhattan
505-984-8001

Quality Inn
3011 Cerrillos Rd.
800-225-5151

Ramada Inn
2907 Cerrillos Rd.
800-272-6232

Rancho Encantado
State Road 592
Tesuque
505-982-3537

Residence Inn Marriott
1698 Galisteo
800-331-3131

Santa Fe Motel
510 Cerrillos Rd.
505-982-1039

Territorial Inn
215 Washington
Ave.
505-989-7737

Water Street Inn
427 West Water
505-984-1193

**Santa Fe
Restaurants**

Cafe Escalera
130 Lincoln Ave.
505-989-8188

Casa Sena
125 East Palace Ave.
505-986-1700

Corn Dance
409 West Water
505-983-3093

Coyote Cafe
132 West Water
505-983-1615

El Nido
Tesuque
505-988-4340

Encore Provence
548 Aqua Fria
505-983-7470

Fabio's
227 Don Gaspar
505-984-3080

Geronimo Lodge
724 Canyon Rd.
505-982-1500

Guadalupe Cafe
313 South
Guadalupe
505-982-9762

Inn of the Anasazi
113 Washington Ave.
505-988-3236

Josie's
225 East Marcy St.
505-983-5311

Julian's
221 Shelby
505-988-2355

La Tertulia
416 Aqua Fria
505-988-2769

La Traviata
95 West Marcy St.
505-984-1091

Maria's
555 West Cordova
505-983-7929

Old Mexico Grill
2434 Cerrillos Rd.
505-473-0338

Palace
142 West Palace
Ave.
505-982-9893

Pasqual's
121 Don Gaspar
505-983-9340

Paul's
72 West Marcy
505-982-8738

Pink Adobe
406 Old Santa Fe
Trail
505-983-7712

Pranzo
540 Montezuma
505-471-2645

Rincon del Oso
639 Old Santa Fe
Trail
505-983-5337

Santacafe
231 Washington St.
505-984-1788

Shed
113 East Palace Ave.
505-982-9030

Steaksmith
Old Las Vegas
Highway
505-988-3333

Whistling Moon
409 West Water
505-473-0338

**Taos Hotels, Motels,
Bed & Breakfasts**

Days Inn
133 Pueblo Sur
P.O. Box 6004
800-325-2525

El Pueblo Lodge
Pueblo Norte
P.O. Box 94
800-433-9612

Hacienda Inn
Pueblo Sur
P.O. Box 5751
800-858-8543

Holiday Inn
P.O. Box V
800-759-2736

Hotel La Fonda
P.O. Box 1447
505-758-2211

Kachina Lodge
413 Pueblo Norte
P.O. Box NN
800-522-4462

Quail Ridge Inn
P.O. Box 707
800-624-4448

Quality Inn
Pueblo Sur
P.O. Box 2319
800-845-0648

Rancho Ramada
615 Pueblo Sur
P.O. Box 6257
800-659-8267

Sagebrush Inn
Pueblo Sur
P.O. Box 557
800-428-3626

Sun God Lodge
Pueblo Sur
P.O. Box 1713
800-821-2437

Taos Inn
125 Pueblo Norte
800-TAOS-INN

**Lodging In and Near
Taos Ski Valley**

Austing Haus
Ski Valley Rd.
Highway 150
800-748-2932

Columbine Inn
Ski Valley Rd.
P.O. Box 736
505-776-1437

Hotel Edelweiss
P.O. Box 83
505-776-2301

Inn at Snakedance
P.O. Box 89
800-322-9815

Thunderbird Lodge
P.O. Box 87
800-776-2279

Taos Restaurants

Apple Tree
123 Bent St.
505-758-1900

Brett House
Ski Valley Rd.
Junction of S.R. 3
505-776-8545

Doc Martin's
Taos Inn
125 Pueblo Norte
505-758-1977

Lambert's
606-758-1009

Michael's Kitchen
North Pueblo Rd.
505-758-4178

Ogelvie's Plaza
505-758-8866

BIBLIOGRAPHY

Beck, Warren A. *New Mexico: A History of Four Centuries*. Norman, OK: University of Oklahoma Press, 1962.

Blacker, Irwin. *Taos*. Los Angeles: Brooke House, 1959.

Coke, Van Deren. *Taos & Santa Fe: The Artists Environment*. Albuquerque: University of New Mexico, 1963.

Drum, Stella. *Down the Santa Fe Trail*. Lincoln: University of Nebraska Press, 1982.

Fergusson, Erna. *Dancing Gods: Indian Ceremonials in New Mexico and Arizona*. New York: Alfred A. Knopf, 1931.

Gibson, Arrell Morgan. *The Santa Fe and Taos Colonies: Age of the Muses, 1900-1942*. Norman, OK: University of Oklahoma Press, 1983.

Hillerman, Tony. *Spell of New Mexico*. Albuquerque: University of New Mexico, 1976.

Horgan, Paul. *The Centuries of Santa Fe*. New York: Dutton, 1956.

Horgan, Paul. *Lamy of Santa Fe*. New York: Farrar-Straus, 1975.

LaFarge, Oliver. *Behind the Mountains*. North Hollywood, CA: Charles Publishing, 1994.

LaFarge, Oliver. *Santa Fe: Autobiography of a Southwestern Town*. Norman, OK: University of Oklahoma Press, 1959.

Luhan, Mabel Dodge. *Winter in Taos*. Denver: Sage Books, Inc., 1935.

Mather, Christine, and Sharon Woods. *Santa Fe Style*. New York: Rizzoli, 1986.

Morrill, Claire. *Taos Mosaic*. Albuquerque: University of New Mexico, 1973.

Nichols, John. *If Mountains Die*. New York: Alfred A. Knopf, 1979.

Noble, David Grant. *Santa Fe: History of an Ancient City*. Santa Fe: School of American Research Press, 1989.

O'Keeffe, Georgia. *Georgia O'Keeffe*. New York: Viking Press, 1976.

Richards, Rick. *Ski Pioneers*. Taos, NM: Dry Gulch Publishing, 1992.

Robertson, Edna. *Artists of the Canyons & Caminos: Santa Fe, the Early Years*. Layton, UT: Peregrine Smith Press, 1976.

Simmons, Marc. *New Mexico*. New York: W.W. Norton & Co., 1977.

Simmons, Marc. *Yesterday in Santa Fe*. Saint Marks, FL: San Marcos Press, 1969.

Steadman, Myrtle. *Adobe Architecture*. Santa Fe: Sunstone Press, 1973.

Warren, Nancy Hunter. *New Mexico Style*. Santa Fe: Museum of New Mexico Press, 1986.

Waters, Frank. *Masked Gods*. Santa Barbara: Swallow Press, 1950.

Weigle, Marta. *The Penitentes of the Southwest*. Santa Fe: Ancient City Press, 1970.

Weigle, Marta and Kyle Fiore. *Santa Fe and Taos: The Writer's Era: 1916–1941*. Santa Fe: Ancient City Press, 1982.

INDEX